S0-ARM-012

Farm Security Administration Photographs of Florida

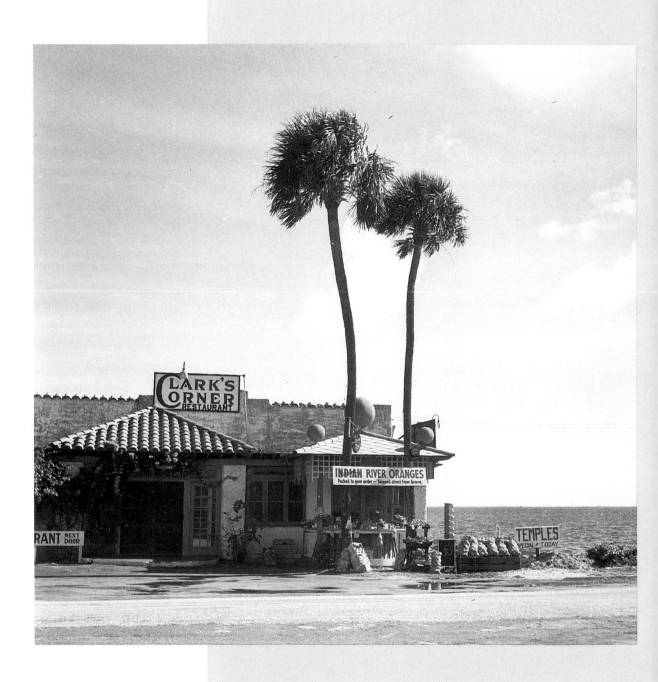

Farm Security Administration

PHOTOGRAPHS OF FLORIDA

*Michael Carlebach and
Eugene F. Provenzo, Jr.*

University Press of Florida
Gainesville/Tallahassee/Tampa/Boca Raton/
Pensacola/Orlando/Miami/Jacksonville

Copyright 1993 by the Board of Regents of the State of Florida
Printed in the United States of America on acid-free paper ∞

Library of Congress Cataloging-in-Publication Data

Carlebach, Michael L.
Farm Security Administration photographs of Florida / Michael
Carlebach and Eugene F. Provenzo, Jr.
p. cm.
Includes bibliographical references and index.
ISBN 0–8130–1212–0 (hard: alk. paper). —ISBN 0–8130–1213–9
(pbk.: alk. paper)
1. Florida—Social life and customs—Pictorial works. 2. Florida—
Rural conditions—Pictorial works. 3. Depressions—1929—Florida—
Pictorial works. 4. Florida—Social conditions—Pictorial works.
5. United States. Farm Security Administration. 6. Documentary
photography—Florida—History—20th century. I. Provenzo,
Eugene F., Jr. II. Title.
F312.C37 1993
975.9—dc20 93-2846
CIP

The University Press of Florida is the scholarly publishing
agency for the State University System of Florida, comprised
of Florida A & M University, Florida Atlantic University,
Florida International University, Florida State University,
University of Central Florida, University of Florida,
University of North Florida, University of South Florida,
and University of West Florida.

University Press of Florida
15 Northwest 15th Street
Gainesville, FL 32611

Frontispiece:

Arthur Rothstein. Cocoa (vicinity). 1937. A roadstand.

LC-USF34-5816-E

[At the time this photograph was taken, Clark's Corner (now
known as Indian River City) had a population of slightly more
than 100 people and consisted of a few stucco houses, filling
stations, and a post office. The town, which is just south of
Titusville, overlooks the Indian River.]

For

Adam and Joshua

(M.C.)

and for

"Bug"

(E.F.P.)

Contents

Preface

*S*ince its inauspicious beginning in a small unit of a minor agency of the New Deal, the photography project of the Farm Security Administration (FSA) has garnered an impressive collection of critics and loyal supporters. The photographs produced by the men and women who worked under the direction of Roy Emerson Stryker are derided by some as pure governmental flimflam and praised by others for their artistic qualities. The FSA images, it seems, are either self-serving propaganda for the Roosevelt administration or the finest example of government-sponsored fine art; in fact, both these characterizations are off the mark.

1 ▪ Arthur Rothstein

Winter Haven. January 1937. The son of a migrant family in the doorway of his temporary home.

LC-USF33-2368-M5

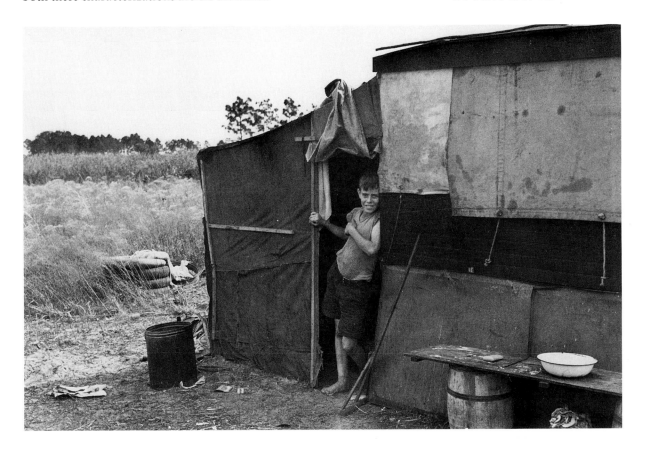

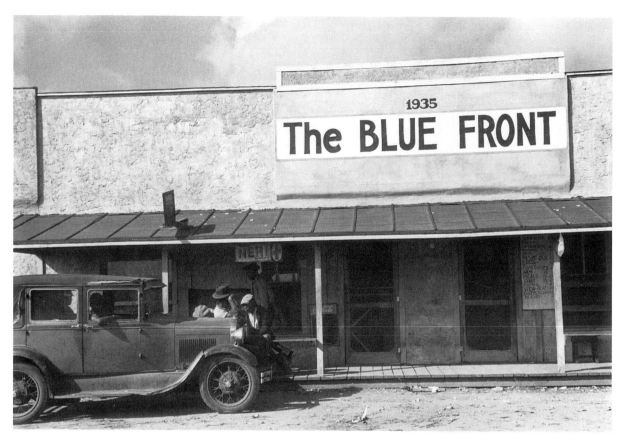

2 ▪ Arthur Rothstein

Belle Glade. January 1937. A restaurant in the Negro section.

LC-USF33-2362-M4

Farm Security Administration photography was government photography. The political value of the images was initially far more important than their aesthetic qualities. Individually and collectively the photographs were used to inform the American people about the lives of the rural poor and to generate support for FSA programs and the New Deal.

In this study we examine the work of the Farm Security Administration in Florida as revealed in photographs made between 1935 and 1943. Our interest is not so much in the personal histories of the photographers who worked in Florida or in the considerable artistic merit of their work, issues that have been addressed in other studies. Instead, our purpose is to provide a social and political context for the images.

We view these photographs as historical and cultural artifacts. The photography project was created in 1935 as part of the Historical Section of the Information Division of the Resettlement Administration. The agency was renamed the Farm Security Administration in 1937. The photographic collection was moved to the Office of War Information in 1942 and is now housed in the Prints and Photographs Division of the Library of Congress. In Florida, photographs by John Collier, Dorothea Lange, Carl Mydans, Gordon Parks, Marion Post Wolcott, and Arthur Rothstein reveal the lives of migrant workers in South and Central Florida, the erosion and misuse of

farmland in northern counties, the decline of the fishing, wood pulp, and timber industries, and Resettlement and Farm Security Administration projects and facilities.

In addition, the Florida collection contains many images of middle- and upper-class life. The effort, especially by Marion Post Wolcott, to document the life-styles of ordinary tourists and of persons living in small towns and villages in the farm belt, juxtaposed to those she called the "idle rich" in Miami and Miami Beach, reveals the breadth and complexity of the collection. Images made for the FSA certainly describe the lives of the rural poor during the Great Depression. The Florida photographs depict as well another Florida, a place where wealthy tourists and affluent Floridians enjoy the good life and where plain folks relax in Mom and Pop trailer parks, sing in church choirs, and play bingo. These photographs really describe lost fragments of American culture. As such, they are worth rediscovering and appreciating.

We wish to thank the following persons who assisted us in the completion of this book. Dr. Luis Glaser, provost of the University of Miami, provided

3 ▪ Marion Post Wolcott

Sarasota. January 1941. Playing "bingo" at a trailer park.

LC-USF34-56989-D

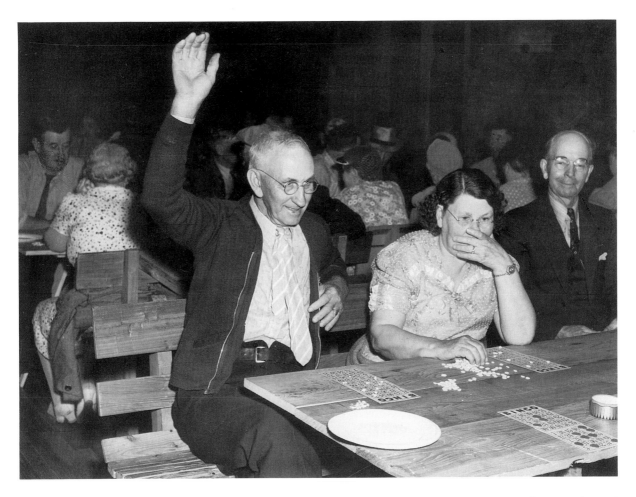

financial support for travel to Washington, D.C., where the friars of Augustinian College were our generous hosts. The staff of the Prints and Photographs Division of the Library of Congress, especially curator of photography Beverly Brannan and Mary Isson, made our work much easier. Special thanks go to Walda Metcalf and Judy Goffman at the University Press of Florida and to Margot Ammidown and Asterie Baker Provenzo.

The Farm Security Administration in Florida

On Friday, March 3, 1933, hours before the inauguration of Franklin Roosevelt, the Great Depression in America reached its symbolic climax. All that day the nation's banks had been shutting down, their resources fatally depleted by weeks of panicked withdrawals and an accumulation of business failures. Herbert Hoover finally realized that he was out of luck and time. That night, having failed to persuade Roosevelt to issue a joint statement dealing with the banking crisis, he admitted bitterly, "We are at the end of our string. There is nothing more we can do."[1]

Roosevelt had no intention of cooperating with Hoover in what he considered to be a futile eleventh-hour effort to stem financial panic. Thus, when Roosevelt took office on March 4, the economic situation was as bad as it would get. Nationwide, agriculture had been suffering for more than a decade, industry and business had been badly mauled in the 1929 stock market crash and its aftermath, and now even the banking system had broken down.

The decline of the nation's farm economy began in 1921, more than a decade before Roosevelt came to power. During World War I farmers were encouraged to borrow large sums of money, purchase new equipment, and open vast new spaces to the plow. Some 40 million acres of new land were added to the agricultural system, much of it only marginally arable. The enormous demand in Europe for agricultural products during and immediately after the war pushed prices ever higher and seemed to promise an enduring marketplace for American farm surpluses. But these markets collapsed in the early 1920s as European agriculture recovered from the devastating effects of the war. Caught between the fixed costs of mortgage and loan payments and falling prices caused principally by the resurgence of European agricultural production, many American farmers found themselves in serious economic difficulty.

The crisis in the agricultural sector was aggravated by a series of tariffs enacted by the federal government in the 1920s and designed to protect American businesses from an influx of low-priced foreign goods. The trend toward higher tariffs culminated on June 17, 1930, when Congress passed the Smoot-Hawley Tariff bill, a disastrous measure that raised the duties on foreign imports so much that retaliation from our trading partners was immediate and severe. According to Henry Wallace, Roosevelt's first secre-

tary of agriculture, the combination of overproduction and high tariffs nearly ruined American agriculture. By 1933, there was no longer an effective foreign market for the huge surpluses of cotton, wheat, lard, and tobacco.[2]

Thus, by the beginning of the Great Depression, no group of Americans was more in need of federal assistance than the farmers. In 1929, for example, nearly 1.7 million farms yielded gross incomes of less than $600 for the entire year. Almost a million grossed less than $400. And in areas such as the cutover lands of the upper Midwest and large parts of the South where sharecropping and tenant farming predominated, nearly 400,000 farms had gross annual incomes of less than $250. Sociologist Carl Cleveland Taylor claimed that fully "one-third of the farm families of the nation are living on a standard . . . so low as to make them slum families."[3]

The national depression, precipitated by the failure on Wall Street, actually began in Florida in the spring of 1926, when the real estate boom collapsed. A fierce, devastating hurricane hit Miami on September 16 that year, deepening the crisis in the housing industry. Two years later, almost to the day, an even deadlier storm struck Palm Beach, then moved into the central region of the state just south of Lake Okeechobee, where an estimated 1,700 persons drowned.[4] Most of those killed were black farm workers, many of Bahamian origin. As a natural disaster, the death toll of the 1928 hurricane was exceeded in the United States only by those of the 1889 Johnstown flood and the 1900 hurricane that hit Galveston, Texas. The storms of 1926 and 1928 wrecked thousands of acres of vegetable and citrus farmland in South and Central Florida and choked off what little remained of the land development and housing markets.

Between 1926 and 1930 the assessed value of real estate dropped by approximately one-third, from $623 million to $441 million. And in the agricultural sector, the sale of farm products dropped from a total of $102.5 million in 1926 to just under $80 million in 1932. Net income of corporations in the state declined from $815 million in 1925 to $84 million in 1930. In 1926, more than forty banks failed; in fact, bank failures continued to occur in Florida until the beginning of World War II. Between 1928 and 1940 a total of 157 banks permanently closed their doors.[5]

During the 1920s, Florida's economic profile was similar to those of other southern states. Its manufacturing capabilities were limited, its population was predominantly rural, and, except for tourism and land speculation, its resources were drawn largely from the agricultural sector. The fevered 1920s land boom in South Florida was deceptive. Although some speculators and developers did exceedingly well, the overall impact on the state's economy was considered by some experts to have been negative. For example, Colin D. Gunn and John Wallace, state land planning consultants for the National Resources Board in Washington, D.C., wrote in 1935 that unregulated speculation in Florida real estate "has been responsible in the past, and . . . will be responsible in the future for countless disrupted lives, and wasted

dollars."[6] When the nation slid into economic depression at the end of the decade, Florida seemed to suffer less than other parts of the country, perhaps because the state's economic figures had been deflated three years earlier.

The economic consequences of the collapse of the land development and housing markets and the hurricanes of 1926 and 1928 were exacerbated by drought in 1927 and an invasion of the Mediterranean fruit fly in April 1929. Precipitation for the year 1927 was nearly twelve inches below the state's annual average of approximately fifty-six inches.[7] In 1927, combined with damage caused by the September 1926 hurricane, citrus production fell by some 3 million boxes. As a result of the fruit fly infestation two years later, citrus production dropped from just over 23 million boxes to 14.2 million. The decimation of the groves by storm, drought, and fruit fly resulted in hard times for many owners and increased unemployment in the agricultural sector.

Ironically, the fruit fly infestation took place at the conclusion of the most successful tourist season in the history of the state. While other parts of the country slid inexorably into economic depression, it appeared to some observers that Florida might already be on the road to recovery. As John Temple Graves wrote in the *New York Times,* until the fruit fly appeared, "there was every reason to believe that the penalties of a collapsed real estate

4 ▪ Arthur Rothstein

Belle Glade. January 1937. In a tourist camp for migratory agricultural workers.

LC-USF33-2361-M3

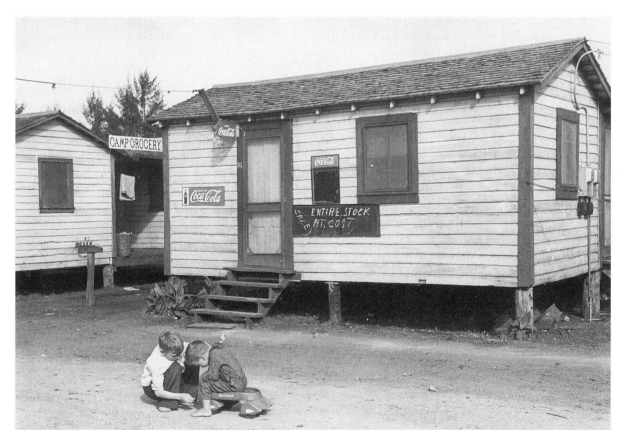

boom and two hurricanes had been paid, and that nothing remained to impede this peninsula from the 'golden round' which had always been its destiny." According to Graves, the threat of agricultural ruin "was a hateful anesthetic" to the reviving spirit of the state and its people and "has been responsible for the nervousness and tightening of credit, which closed nearly thirty banks recently within as many days."[8]

The depression in Florida did indeed persist. The income of Floridians declined steadily during the early 1930s. Per capita income was $510 in 1929, $478 in 1930, $392 in 1932, and a low of $289 in 1933. By the end of 1933, 26 percent of the state's population was receiving public assistance from either state or federal sources. To be sure, hard times in the state were neither uniform nor unchanging, even in the farming areas. Tourism was a palliative to economic depression in the urban centers along the coasts, and there were occasional signs of improvement in the agricultural sector. In 1934, the editors of the *Florida Grower,* a journal published by and for some of the state's largest agricultural enterprises, argued that conditions in Florida were fundamentally sound and that the state represented an "agricultural empire" that deserved special attention by the country's business leaders.[9] But in spite of the concerted efforts of local and state officials to downplay or deny outright evidence of economic hard times, many Floridians suffered along with the rest of the nation.

Even Florida's normally ebullient commissioner of agriculture, Nathan Mayo, admitted in 1938 that farmers had been hard hit during the past decade. In *A Graphic Review of Florida Agriculture,* published in July 1938, Mayo pointed out that from 1900 to 1925 the value of agricultural property had steadily increased. However, that all changed after the collapse of the land boom in South Florida: from 1930 to 1935, the per acre value of farm land fell from $84.22 to $53.08, a staggering decline of 37 percent.

Despite the financial collapse of 1926, certain areas of Florida's agricultural economy improved during the early years of the depression. Critical to this expansion was the discovery early in 1928 that the addition of copper sulphate to the heavy, black, and previously unproductive South Florida soil made it far more fertile, although taking advantage of this innovation required enormous outlays of capital for specialized equipment to drain and irrigate the land. As a result, the principal beneficiaries were entrepreneurs who established huge vegetable and fruit farms employing thousands of migrant laborers. The opening of this vast region to agriculture, combined with the advent of rapid rail transportation and refrigeration, made Florida the East Coast's main source for fruits, sugar, and winter vegetables.[10] State land planners were enthusiastic. In a report issued in 1935, they noted that in the Everglades farmers "are able to market during periods of highest prices, and production costs are lower than elsewhere."[11]

The introduction of agribusiness into Florida brought with it a new model of farming, one characterized by immense landholdings that depended upon low-paid seasonal workers to perform most of the harvesting. In this system, production was as much an issue of market speculation, options, and futures

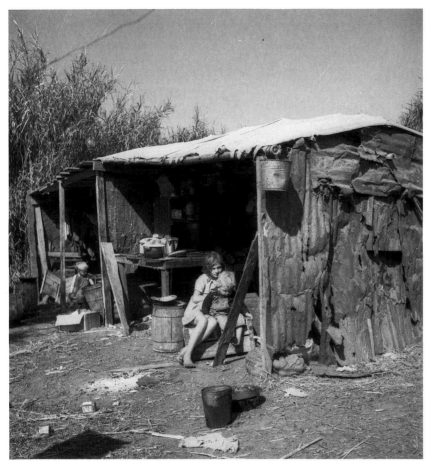

Belle Glade. January 1939. A migrant packing house worker's camp in a swamp cane clearing. Two families from Tennessee are living here. There are no lights, nor water, nor privy. Water for cleaning is hauled from a dirty canal and drinking water is hauled from the packing house.

LC-USF34-51072-E

as it was of the planting, growing, and harvesting of crops. Factory farming also led to the organization of a fully developed migratory cycle on the East Coast of the United States. Migrant laborers could now follow the planting and harvesting of the crops beginning in Florida in the winter and moving up the East Coast as the season progressed.

The intensity of the farming effort in southeastern Florida is indicated in figures cited by Carey McWilliams. His 1945 study of migrants and migratory labor in the United States reported that in the area around Lake Okeechobee 80,000 acres of palmetto scrub and swampland were reclaimed by federal drainage projects for farming. Three to four crops a year could be grown on this land; a full crop of beans was ready for harvest in as few as forty-two days. Up to 50,000 migratory workers were employed on these new farmlands.[12]

The rapid growth of large-scale agriculture during the 1930s in the areas south of Lake Okeechobee is shown by the evolution of farm communities like Belle Glade and Pahokee. Before the hurricane of 1928, these towns consisted of little more than a few modest wooden houses, a general store, and a one-pump gas station. By the early 1940s, however, each had a

6 ▪ Arthur Rothstein

Belle Glade. January 1937. A bean advertisement.

LC-USF34-5848-E

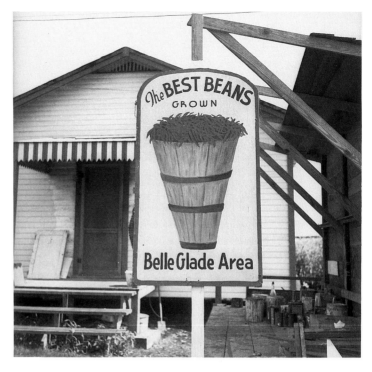

7 ▪ Marion Post Wolcott

Belle Glade. February 1939. Migratory packing house workers waiting around the post office during the slack season.

LC-USF33-30450-M4

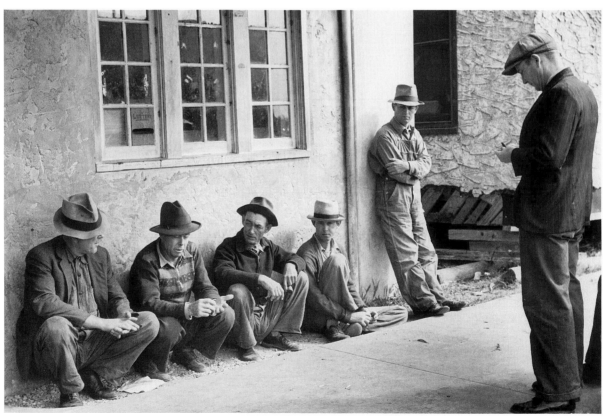

permanent population of over 4,000, which easily doubled during the winter months as black and white migrant workers poured into the area to harvest the crops.

In the 1939 *WPA Guide to Florida,* Pahokee was described as a major shipping point for vegetables, where acres of warehouses, loading platforms, and the offices of produce brokers were intermingled with wood-frame business buildings and rooming houses. Several general stores carried everything from tractors to silk stockings. From Christmas until April, according to the *WPA Guide,* "Pahokee is a 24-hour town; long trains of refrigerated cars roll out for northern markets day and night; the streets are noisy and crowded; bars, restaurants and gambling places are seldom closed."[13]

The fertility and productivity of the new farmlands in Central Florida was legendary. One popular story published in the *WPA Guide* described the experience of two black children during planting season. As they walked down the newly turned rows early one morning planting seed corn, they "discovered that it was sprouting immediately behind them. One boy shouted to the other to sit down on some of the seeds so that all of the corn would not grow to fodder before they finished planting. Next day the sitter dropped down a note, 'Passed through Heaven yesterday at 12 o'clock, sellin' roastin' ears to angels.' "

White migrant workers in Central Florida were usually employed in packinghouses at a rate of thirty cents per hour. Field-workers, most of whom were black, were paid between fifteen and thirty cents per filled hamper. With two adults working, a white migrant family could make between ten and fifteen dollars a week. Two blacks working together could make between nine and thirteen dollars. Many white migrants were sharecroppers and tenant farmers from other southern states who worked in Florida during the winter months while their home fields lay fallow. They were attracted by warm winter weather and the promise of decent salaries. Once in Florida, however, migrants found that actual pay was low and living conditions deplorable. The best-paid migrants earned about forty cents an hour before the depression, compared to twenty-five cents per hour during the depression.

The lives of black seasonal workers are compellingly described in Zora Neale Hurston's 1937 novel, *Their Eyes Were Watching God.* She describes the boomtown, frontier atmosphere of Central Florida as ragged migrant families, "permanent transients with no attachments," found their way into the new market towns around Lake Okeechobee and the arrival of hordes of "tired looking men with their families and dogs in flivvers. All night, all day, hurrying in to pick beans. Skillets, beds, patched up spare inner tubes, all hanging and dangling from the ancient cars on the outside and hopeful humanity, herded and hovered on the inside, chugging on to the muck. People ugly from ignorance and broken from being poor."[14]

The migrants described by Hurston, who was raised and is buried in Eatonville, just north of Orlando, were in large part an invisible people. Rarely seen on major roads or thoroughfares, in the city centers, or tourist

8 ▪ Arthur Rothstein

Fort Pierce. January 1937.
Packing fruit.

LC-USF3301-2342-M5

areas of the state, they lived on the margins of Florida society, and the dreadful living and working conditions that they endured were often ignored by state and local officials. Carey McWilliams noted that seasonal workers developed "an extraordinary faculty for making themselves inconspicuous; they are the least noticeable of people and the most difficult to locate." To avoid the enmity of local officials, they stayed "in the cheaper auto and tourist camps or in some squatters' camp off the main highways." And when even the cheapest campgrounds were too expensive, migrants found secret places in which to stay: "in a clump of trees or under a bridge or around the bend of a stream out of sight."[15]

Seasonal workers and other rural poor remained inconspicuous for good reason. In many areas of the country, including Florida, the dispossessed, the unemployed, and the homeless were confronted by local law enforcement organizations and vigilante groups who were determined to eradicate labor unrest and poverty by forcing the poor to leave town. Many state and local politicians were unsympathetic, even hostile, to the impoverished citizens in their midst, for there was a widespread conviction that the unemployed were merely malingering or organizing for the Communists or both. Welfare payments were viewed by many conservatives as wasteful and destructive of

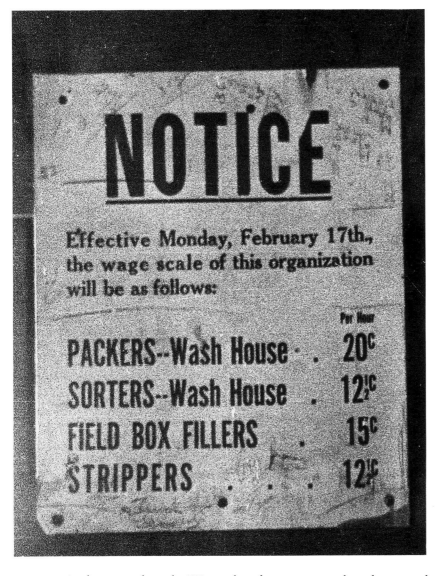

Sanford. January 1937. Notice to celery workers.

LC-USF33-2350-M3

proper attitudes toward work. "Unemployed men contemplate the ease of life of those who are supported in idleness and relax their own efforts," reported the editors of *Nation's Business* in January 1933. "There is loss of ambition among those who, forced to go on the dole temporarily, lose their will to work and remain there."[16]

Poor people who came to Florida looking for work were not welcome. One attempt to deal with the newly arrived unemployed was called the "Hobo Express." It worked, according to a contemporary commentator, as follows: "The sheriff from Miami gathers up a truckload of men and boys each morning and takes them to a northern county line. The sheriff from Fort Lauderville [*sic*] meets them and transfers them to Palm Beach County." The process was repeated all the way to Brevard County, where

the chain ended as that sheriff "does not meet the express, and it is known that Mr. Hobo eventually makes his way back to the place from which he was first started."[17]

The contrast between the prosperity of the new farmer-growers in South and Central Florida and the abject poverty of most of the farm workers was not lost on some members of the press. For instance, in an article from the files of the Farm Security Administration entitled "Cranberries, Tomatoes, Potatoes and Onions," which was reprinted in the *Pilgrim Highroad* (July 1940), Violet Wood reported that migrants in Florida lived "in shacks, box-cars on railroad spurs, roadside tents, home-made trailers and old Fords." Wood describes how in Glades, Florida, which had some of the richest farmland in the country, she saw six white children and four adults living in a 12-foot-by-12-foot rainbreak in a grass clearing, with four poles supporting a roof made of scrap tin and with walls made of potato sacks and flour bags. In another section of the state she saw seventy-seven black men, women, and children living in a long, narrow, windowless hut built like a stable.[18]

Ironically, although migrant housing in Florida during the depression was deplorable, workers had to return a considerable portion of their earnings to landowners in the form of camping fees or temporary rent. In the Belle Glade

10 ▪ Marion Post Wolcott

Miami. February 1939. A crowd at the horse races at Hialeah Park.

LC-USF3301-30461-M4

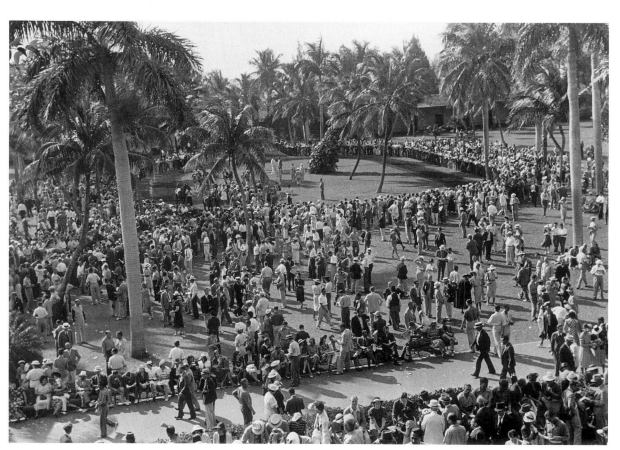

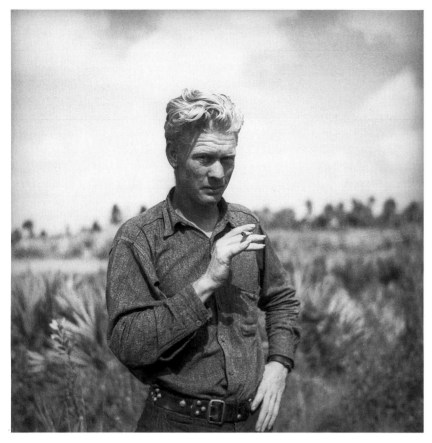

Deerfield. January 1937. A migrant worker from Oklahoma.

LC-USF34-5833-E

area seasonal farm workers were charged from four to six dollars a month to camp on private land. A. F. Smith of the Florida Industrial Commission reported in 1940 that "migrant workers must sleep in shacks, boxes, in cars, tents or trailers, in trucks on the ground, or wherever it is possible to rest. They have no facilities for washing and no toilet facilities of any kind are provided. . . . Sanitary and living conditions found this spring in the Lake Okeechobee area were beyond description."[19] In the worst camps, open-pit toilets were located next to the only available water supply. Local and state housing, health, and sanitation regulations were rarely enforced. During the late 1930s, major efforts were undertaken by the Farm Security Administration to establish model camps for migrant farm workers at Osceola and Belle Glade. Given the magnitude of the problem, their efforts proved only partially successful.

Economic and cultural contrasts were greater in Florida than in most other states of the Deep South. Because of its proximity to the Caribbean and the influence of Cuban and Bahamian cultures, Miami was a cosmopolitan urban center with a burgeoning tourism industry. Yet just a few miles to the south were the bean and tomato fields of Homestead and Florida City. And two hours north by car was Palm Beach with its opulent beachfront estates and rococo country clubs, flanked to the west of Lake Worth by thousands

of acres of cultivated fields. The contrast between wealthy tourists and indigent migrant farm workers was striking. "As winter tourists flock in Miami," wrote McWilliams, "an army of migratory workers assembles in the Everglades. As thousands of workers assemble, the area takes on the appearance of an early-day mining community in the West. It is a camp where people mine carrots, beans, peas, and tomatoes."[20]

During the 1930s, both the dispossessed and affluent came to Florida in search of the good life. The lack of adequate relief programs in other states and the possibility of finding at least temporary work in the fields were powerful magnets for many of the 2 million farmers who between 1929 and 1934 found it necessary to work away from their farms. In this context, the experience of Florida during the depression, particularly in the central and southern regions of the state, was similar to that of California. The photographs in the files of the Historical Section of the Farm Security Administration most clearly illustrate this situation. The faces of the invisible poor—families in search of work, farmers trying to eke out a living on submarginal land—were the principal subjects for photographers in both states. In Florida, however, the life-styles of tourists and the idle rich provide a stark contrast to the images of poverty.

■ ■ ■ ■

By the time Roosevelt took office, the situation in the agricultural sector of the economy was critical. Economists Rexford Tugwell and Howard Copeland Hill reported that by the end of the 1920s most American farmers were in deep trouble. "About $1400 to $1800 a year was found necessary from 1919 to 1930 to keep a farm family of five above the level of poverty. . . .[Now] we find that for the country at large the average income has been less than $800 per farm family, that over three-fourths of farm families live on the poverty level, and that over one-half live in the most extreme poverty."[21] The president was convinced that economic recovery was impossible as long as agriculture remained moribund. "We cannot have national prosperity," he said, "without farmer prosperity."[22]

Reviewing trends in farm incomes during the 1920s, the Farm Security Administration reported that "after 1920 the prices received by all farmers declined in relation to the retail prices of goods they had to buy." An increasing number of farmers fell "into the category of those whose receipts for the sale of their products were too small to provide them with a decent standard of living."[23] Thousands of farmers were bankrupted. Many left the land altogether, searching for new lives in the sprawling industrial cities of the Midwest and Northeast. Others became tenants or sharecroppers. Then, as automated farming practices, especially the use of tractors and multirow equipment, reduced the need for hired help, even caretaker farmers were forced from the land. When drought, wind, flood, and erosion drastically curtailed production in the early 1930s, the hardest hit were those who could least afford it: subsistence farmers with small holdings, sharecroppers, and tenant farmers. Those who had managed somehow to withstand economic

pressures, the low prices they received for their produce and high production costs, were now devastated by the uncertainties of nature. Thousands more left the land, heading for already crowded cities or the green fields of California or Florida.

On February 16, 1937, President Roosevelt spoke to Congress about the crisis in the agricultural sector. "Thousands of farmers commonly considered owners, are as insecure as tenants," he said. The trend in the countryside was toward corporate ownership of what were once family farms. "When fully half the total farm population of the United States can no longer feel secure," said Roosevelt, "when millions of our people have lost their roots in the soil, action to provide security is imperative."[24]

Like California, Florida was unprepared for the influx of dispossessed farmers and agricultural workers from other parts of the country; in fact, the state was overwhelmed by the plight of its own farm population. Particularly in northern Florida, farm workers were stranded and without work. The decline of forest resources led to a serious shortage of work among sawmill, timber, and turpentine workers. Increasingly automated farming methods further reduced the demand for labor. To make matters worse, a significant portion of farmland in Florida was only marginally productive; in order for

12 ▪ Arthur Rothstein

Sanford. January 1937. Celery harvesting is usually done by two crews; one rests while the other works up and down the field.

LC-USF33-2348-M3

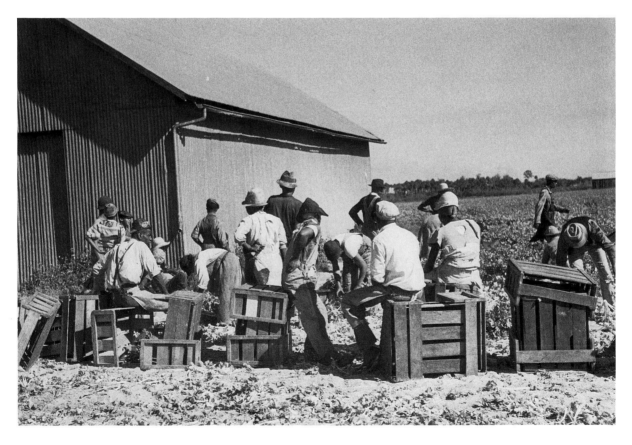

full economic recovery to take place, it would be necessary to retire the least productive agricultural areas and devote them to other uses.

As one-crop subsistence farming in Florida was decimated by economic and natural forces, it was often replaced by the mass-production techniques of agribusiness and factory farms. This was true particularly in the central and southeastern portions of the state. The shipper-grower, a new breed of entrepreneur, began to take the place of the independent yeoman farmer, especially in Central and South Florida. Driven to desperation, poor farmers, migrants, and sharecroppers banded together to fight back.

At foreclosure sales across the country, farmers united to buy back their property from the banks and insurance companies. In April 1933, for instance, 30,000 farmers in Nebraska threatened a "starvation strike [that would] surpass in violence and bloodshed any previous organized revolt by the Western farmers." In Minnesota one farm leader announced, "In our part of the country when a sale comes on, we warn people that anyone buying a place won't find life worth living."[25]

In the South, suspected union organizers and sympathizers were harassed and sometimes brutalized. When the tenant farmers and sharecroppers of Arkansas formed the Southern Tenant Farmers Union in 1935, local land-owners responded with a state-supported campaign of terror. In Florida, sporadic efforts to organize the citrus industry were often countered with violence. Frank Norman of Orlando, who attempted to establish an independent union for citrus workers during the early 1930s, was kidnapped and presumably murdered. The weakness of organized labor in Florida in general during this period is indicated by the fact that only 20 percent of the employed belonged to a union. From 1916 until 1932, a period in which 31,625 labor disputes were recorded in the United States, Florida had a total of only 159 disputes, less than one-half of one percent of the total.[26]

Roosevelt and his advisors believed that there was no chance of general recovery as long as so much of American agriculture remained impoverished. The president attacked the depression with a wide variety of programs, policies, and legislative maneuvering—efforts that were held together by his belief in the interdependence of the economic sectors of the nation. As his advisor Raymond Moley explained, Roosevelt believed that "in a civilization that is tied together by modern conditions each part is dependent upon all others."[27] Helping one segment of society would help the others. The administration proceeded on two fronts: the Agricultural Adjustment Administration (AAA), created by the Agricultural Adjustment Act in May 1933, was designed to help the agricultural community as a whole; the Resettlement Administration, created by executive order in 1935, was conceived to aid the poorest members of the rural community, the share-croppers, tenants, and migrants.

At the core of the AAA was the domestic allotment program. Anathema to conservatives, this program was intended to raise farm prices by curbing overproduction. Farmers received subsidies from the federal government for removing portions of their acreage from production or limiting their num-

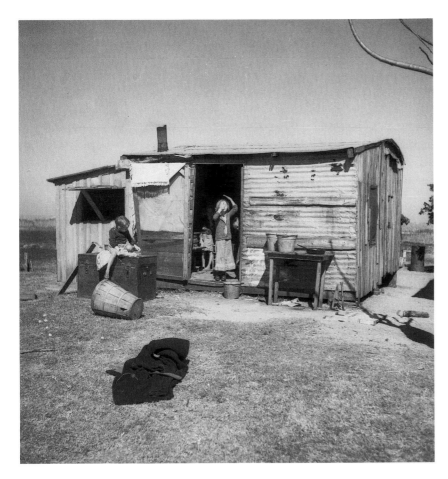

Belle Glade vicinity. January 1939. The home of a migrant agricultural laborer who has six children.

LC-USF34-51019-E

bers of livestock. In some cases they were paid to destroy crops already harvested. Domestic allotment combined with the AAA's other programs—benefit payments to farmers, loans for conservation, and the purchase of farm surpluses for distribution through relief channels—had an immediate and beneficial impact.[28]

In Florida and elsewhere, the AAA worked especially well for large, established farms. According to an October 1934 editorial in the *Florida Grower*, the marketing agreements of 1933 and 1934 "considerably increased returns realized by growers" and promised "to put some profit in the production of most Florida farm crops." For tenant farmers, sharecroppers, and subsistence farmers working on marginal land, however, the new programs offered little hope. In some cases, agricultural adjustment actually worsened the lot of the poorest third of the farm community. For instance, some owners of large farms worked by tenants used the money they received from the government to buy labor-saving equipment that enabled them to reduce the size of their work force.[29] For farmers working small plots in unproductive areas, the domestic allotment provisions offered practically nothing. These people needed something more. As long as they remained on their wasted land, there could be no hope for the future.

Tenant farmers and sharecroppers were, if anything, even worse off. Although in principle allotment payments for crop or livestock reductions were to be divided between landowner and tenant, it seldom happened because the final bill contained no written provisions guaranteeing an equitable distribution. Landowners gladly accepted payments for taking land out of production, but their tenants usually received nothing. In the South, where as many as 75 percent of the farms were worked by tenants, the displacement caused by domestic allotment was staggering. "In '34 I reckon I had four renters and I didn't make anything," said one farmer. "I bought tractors on the money the government give me and got shet 'o my renters. . . . The renters have been having it this way ever since the government come in."[30]

In order to combat poverty that was unaffected or even aggravated by provisions of the AAA, on April 30, 1935, Roosevelt signed Executive Order 7027 creating the Resettlement Administration (RA). The new agency was a child of the "Second New Deal," a period beginning in 1935 during which programs were adopted that were designed to aid those who had not benefited from earlier New Deal measures. Besides the RA, this phase produced the Works Progress Administration (WPA), Social Security, and the Labor Relations Act.

According to Rexford Tugwell, a former professor of economics at Columbia University appointed by Roosevelt in 1935 to head the new agency, the RA's basic job was to "assume the same responsibility for indigent rural folks as [Harry] Hopkins' Works Progress Administration . . . was to assume for the urban poor." The RA functioned in three areas: it created and administered projects involving the transfer of destitute and low-income families from unproductive rural areas; it administered environmental projects dealing with soil and seacoast erosion, water pollution, flood control, and reforestation; and it financed, in whole or in part, the purchase of land and equipment by indigent farmers, tenants, and sharecroppers.[31] The RA also set up and administered communal farms for displaced families and established several rural communities. Camps for migrant workers were built and maintained, providing them with decent housing, clean facilities, and low rents. Loans were made to farmers, who were encouraged to buy land in areas where soil fertility was assured and markets accessible.

Tugwell discarded as hopelessly romantic the idea that farming was an individualistic enterprise, and he believed an endless expansion of agricultural productivity was wishful thinking. While a laissez-faire philosophy toward agriculture may have been successful in the entrepreneurial flowering during the last half of the nineteenth century, he believed that the modern world necessitated a shift away from the ungoverned exploitation of natural resources: "The need for public control is predominant."[32]

Because it was created by executive order, the RA was independent of the Department of Agriculture and the rest of the federal bureaucracy; it had no formal legal sanction or civil service status. Even Tugwell had an ambiguous position, since he retained his title of undersecretary of agriculture while

working full-time for the RA. Regardless of its initial administrative obscurity, the agency's employees shared the notion that the debilitating effects of rural poverty could be mitigated through federal intervention. Farm ownership would become an option for tenants, wrote Tugwell in the *New York Times Magazine* on January 10, 1937, and, most important, the RA would provide "treatment for disease, better diet for children, a mule, some seed and fertilizer, clothes to lift the shame of going ragged to town, some hope for the future, a friendly hand to help in every farm and home crisis."

Many of the projects of the RA were controversial. In particular, communal farms, migrant labor camps, and suburban resettlement projects, which were dubbed "Tugwell Towns," were viewed by conservatives as overtly communistic. In fact, Tugwell's unbending commitment to collectivist solutions to modern economic problems offended practically every vested interest. Business leaders were predictably suspicious, but so were some union organizers who feared the establishment of government-owned and -operated rural sweatshops. Tugwell's supporters argued that attacks against him

14 ▪ Arthur Rothstein

Withlacoochee Land Use Project. February 1937. A submarginal farm.

LC-USF34-25077-D

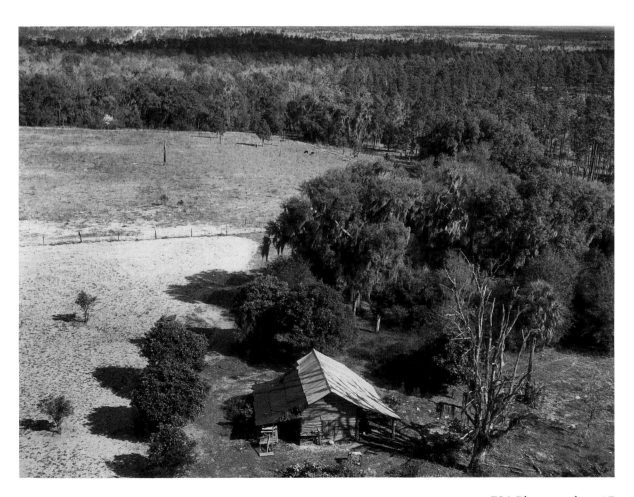

15 ▪ Arthur Rothstein

Withlacoochee Land Use Project.
January 1937. A fire-fighting crew
getting ready to put out a fire.

LC-USF33-2387-M3

and the RA were inspired by special interests who saw in the federal plans a threat to their own power.[33]

By 1935, there were 15,000 farms in Florida that earned less than $400 per year. During the mid-1930s, the RA bought up approximately 600,000 acres of the state's poorest lands and converted them into forests, wildlife areas, recreational lands, and grazing districts with labor for these projects provided by the Civilian Conservation Corps (CCC). Established in 1933, the CCC was the first New Deal agency to operate in Florida. By the time the agency was terminated in 1942, more than 50,000 men between the ages of eighteen and twenty-five had been employed. During the nine years that the program was in operation, they were responsible for planting millions of trees, improving forests, and clearing thousands of miles of firebreaks. In all, the federal government spent more than $30 million on the CCC's Florida operations.[34] In the 1938 annual report of the State Welfare Board, the impact of the CCC on both individual families and the economy of the state was glowingly described. With monthly wages of $25 for each of the 5,698 workers employed in 1938, more than $1.7 million in federal funding, "an important and tangible asset," had been poured into the state.[35]

Without the help of the CCC, the four major Resettlement Administration projects in Florida could not have been undertaken: the Wakulla Agricultural Demonstration Project near Tallahassee, the Withlacoochee

River Agricultural Project in the Panhandle, and a combination reforestation project and wildlife preserve that stretched across Escambia, Santa Rosa, and Okaloosa counties. In addition, the RA established the Welaka Wild Life and Conservation Project in Putnam County, which consisted of 2,640 acres of slash and longleaf pine, 84 acres of fish-breeding ponds, and a game farm with the potential of raising 5,000 quail annually. The projects involved the purchase of 574,176 acres of submarginal farm and timber land and provided work for more than 2,800 men who might otherwise have been on the relief rolls.[36]

For the Wakulla project, 262,000 acres of land were optioned in Wakulla and Leon counties. Formerly a rich area of pine forests with some cypress and native hardwoods, it had been clear-cut several times since the region's first settlement and could no longer support farming or timbering activities. In addition, fires and the destruction of trees for turpentine production had contributed to the decline of the area. A portion of the land was later added to the St. Marks Migratory Waterfowl Refuge; the rest was turned over to the U.S. Forest Service as an addition to the Apalachicola National Forest.[37]

The Withlacoochee project involved the restoration of approximately 113,000 acres of land, 45,000 acres of which were set aside as pasture for cattle. RA activities in Escambia, Santa Rosa, Okaloosa, and Putnam counties differed from the Wakulla and Withlacoochee projects in their emphasis on the development of fish and game resources, which provided badly needed alternative uses for submarginal farmlands.

The Resettlement Administration also helped establish small farms on which displaced farmers or those cultivating unproductive land could be resettled. Near Pensacola, where unemployment soared as a result of the decline of the lumber industry, farms of approximately 100 acres, including a four-or five-room frame house, a barn, and outbuildings, were made available to a small number of farmers. As L. C. Gray, chief of the Land Policy Section of the RA, explained, "These people . . . need funds and they often need technical help. The government is offering them both. It is making them loans and it is giving them advice on the best methods of working their land. It is testing their soil to determine whether or not it is suitable for certain crops, it is helping them select the correct fertilizer and the best seed." By January 1, 1937, the Resettlement Administration had loaned more than $1,482,000 to approximately 8,000 farmers throughout the state. With this money, basic farm improvements were made and new methods of farming undertaken.[38]

The Rural Rehabilitation Division carried on the bulk of the activities of the agency. The purpose of this unit was to give farmers the technical and financial assistance necessary to enable them to increase productivity. In cases in which damaged land was deemed salvageable, the Land Utilization Division also offered a combination of financial assistance and education in proper cultivation techniques. Only those whose land was considered to be viable, however, were eligible for help from these divisions. Families living on submarginal or ruined land were relocated by the Rural Resettlement

Division. Land that could not be farmed was retired. In all, during the 1930s the federal government purchased 9 million acres nationwide and turned them into nonagricultural areas such as wildlife and forest preserves and recreational areas. According to Tugwell, the objective was not so much to provide outdoor space for leisure activities as to retire unproductive farmland. In 1936, Tugwell wrote that eastern land that is "hopeless for farming, can be used for other purposes with greater social values."[39]

Because he was continually enmeshed in controversy, Tugwell believed that one of his main tasks would be to persuade Congress and the public that the RA's projects were necessary. Without support from Capitol Hill, the RA would wither and die. Tugwell established an Information Division, the purpose of which was to explain and publicize the agency's positive accomplishments. It would be the public relations arm of the Resettlement Administration. Such a unit was necessary not only because of Tugwell's penchant for taking politically sensitive positions but also because the RA's constituency was virtually powerless and bereft of electoral influence.

In order to build and maintain friendly relations with the taxpayers, the staff of the Information Division was directed to supply materials to newspaper and magazine editors and radio station managers and to prepare and disseminate visual displays designed to educate the public. Thus the impetus

16 ▪ Arthur Rothstein

Withlacoochee Land Use Project. January 1937. The planting crew arriving at the reforestation area.

LC-USF33-2385-M5

to create the extraordinary collection of documentary images of the depression in America came from Tugwell. The director realized that photographs could be used effectively to describe the work of the agency. While teaching at Columbia, he had become a proponent of "descriptive economics," by which he meant that illustrations, especially photographs, should be used to tell the economic story of the nation. His students were bombarded with charts, graphs, and photographs—anything, in fact, that could describe the institutions they were studying. "This was such a tragedy and so widespread," Tugwell said in an interview in 1965 with Richard Doud of the Archives of American Art. To be able to use pictures to analyze and to explain the hard times in the American countryside was, he said, "a thrilling experience." Tugwell's wife, Grace, who had worked as an administrative assistant in the Labor, Special Skills, and Informational divisions of the agency, concurred. "It was the only way to do it," she told Doud. "Words were simply not enough."[40]

Tugwell hired Roy Emerson Stryker, with whom he had worked at Columbia University, as head of the Historical Section of the Information

17 ▪ Marion Post Wolcott

Belle Glade. June 1940. Supervised play hour for younger children in the assembly building at the Osceola Migratory Labor Camp, a Farm Security Administration project.

LC-USF34-54114-D

Division. His principal job would be to collect and disseminate photographs. Years later, Stryker recalled an early discussion with his boss about the use of pictures. "One day he brought me into the office and said to me, 'Roy, a man may have holes in his shoes, and you may see the holes when you take the picture. But maybe your sense of the human being will teach you there's a lot more to the man than the holes in his shoes, and you ought to try and get that idea across.' "[41]

This conversation occurred in the summer of 1935. Stryker began to organize. His job description stated that he must direct the activities of sociologists, economists, investigators, statisticians, and photographers, all of whom were engaged in describing various aspects of the RA. There was an enormous amount of ground to be covered. In fact, Stryker could proceed in any one of several directions. "The government brought Stryker down to Washington as a historian," according to Arthur Rothstein, the first photographer to work in the Historical Section. "He could have made a history in words, but he was visually oriented, . . . a great believer in the visual right from the beginning."[42]

Like Tugwell, Stryker was an advocate of visual description and education. But despite the fact that his work at the Resettlement and Farm Security

18 ▪ Marion Post Wolcott

Homestead. January 1939. Main street, in the Negro section.

LC-USF34-50960-E

22 FSA Photographs

administrations would have an enormous impact on American photography, he was no photographer. "I always had a camera," he told historian Nancy Wood, "but I had no more business with that damn Leica than with a B-29." He would never compete with his photographers.[43]

Tugwell "gave me my great chance," Stryker wrote in 1951. "He wanted to prepare a pictorial documentation of our rural areas and rural problems, something that had always been dear to my heart." But the job was not simply to collect pictures. From the start, Tugwell stressed the educational and persuasive aspects of the job. "Tugwell put it this way," said Stryker. " 'Roy, you've got a real chance now to tell the people of America that those in distressed areas are the same as everybody else except they need a better chance.' " For the next eight years, until 1943, Stryker and his photographers carried out that directive, making and disseminating images that explained America to Americans while they raised public and congressional support for FDR's more controversial farm programs. "It was a troubled period," he said, looking back from the vantage point of the sixties. "There were depressed areas, depressed people. Our basic concern was with agriculture—with dust, migrants, sharecroppers. Our job was to educate the city dweller to the needs of the rural population."[44]

■ ■ ■ ■

When Stryker arrived in Washington in the summer of 1935 to assume control of the Historical Section, he had no idea that eight years later he would be hailed as the moving force behind the greatest visual documentation of the American people ever accomplished. In fact, in the early days Stryker really had no reason to believe that his work would be confined to the organization and direction of photographic activities within the RA. "Some have thought [the photography project] was a master plan of the New Deal to document the life of the nation," he wrote in 1960. "There was no master plan." The photographic work of the Historical Section "happened as it grew," like Topsy.[45]

The impetus for Stryker's switch from general historian to director of photography came from Tugwell. The purpose of the Resettlement Administration was "not only to bring the resources of government to the assistance of those who were distressed or starved out," said Tugwell, "but to make certain that never again should Americans be exposed to such cruelties." It was important that the "incredible events of those years" be recorded, he added, "and the best way was to photograph them." Thus Stryker's efforts were narrowed to the collection of still images that would depict not only the brief history of the Resettlement and Farm Security administrations but also an eight-year slice of American history.[46]

Stryker began to build a staff and to organize a program. He hired Arthur Rothstein, who had just graduated from Columbia, and together they established a working rationale for the Historical Section, though neither had an inkling of the future importance of the project. "We had little time to think that we had a place in history," Stryker said. "We were busy with our

day-to-day and week-to-week assignments."[47] Rothstein had worked with Stryker at Columbia, and in 1934 they had compiled a photographic record of American agriculture from images in the files of the Department of Agriculture. Rothstein had planned to enter graduate school in medicine or chemistry—photography was an avid interest, not a career goal. Still, his knowledge of the mechanics of photography and a familiarity with the photographic needs of the Historical Section made him a valuable commodity.

In the reshuffling that followed Tugwell's decision, Stryker gained the services of two photographers who would add significantly to the work of the photography project, Carl Mydans and Walker Evans. Mydans's background was in journalism. He had graduated in 1930 from the Boston University School of Journalism, and had worked part-time for both the *Boston Globe* and the *Boston Herald*. In 1931, he joined the staff of a small daily newspaper in New York City, the *American Banker*. His journalistic efforts up to this time had been confined to the written word. In New York, however, he began to illustrate his articles with photographs and to sell images to a variety of publications, including *Time*. Although he managed to have many photographs published, there was resistance among magazine editors to his use of the small-format 35mm camera. This hand-held instrument was thought by many to be more toy than camera, and the pictures it produced were disparaged as too grainy. But Mydans persisted.[48]

His break came when a friend at *Time*, Daniel Lonwell, told him about the work being done in the Suburban Resettlement Division of the RA. He was interviewed and hired to produce photographs for a book describing the division's work. Although the project was never completed, Mydans's Suburban Resettlement images were not lost. They were transferred to the files of the Historical Section when all photographic work in the RA was consolidated under Stryker.

In November 1936, Mydans left the RA to work as a staff photographer for the newly created *Life* magazine. Although he had only a brief tenure as a government photographer, his contribution was significant. Stryker recalled seeing Mydans's work for the first time: "Carl came in with hundreds of feet of 35mm film. I had never seen anybody take so many pictures! We had to spread everything out on the floor of the office just to see what he had. It was wonderful!" Mydans's easy-going approach to people and his training as a journalist perfectly suited his work with small-format cameras. Shortly before he left on his first long trip for the RA, Stryker advised him to concentrate on subject matter that fit his photographic methodology. "I want you to take pictures of everything you can find of what's happening to the people," Stryker said. "I think you are going to find it in the faces of the people."[49] During his tour through resettlement projects in northern Florida in June 1936, Mydans concentrated on making images that showed the effects of overfarming on the land. In a tangle of abandoned farm buildings near Brooksville, Mydans saw both human erosion and hope for the future,

for the ravaged land was now being used as part of the Resettlement Administration's land renewal projects.

Stryker demanded that his photographers produce effective images, not that they adhere to a particular style or technique. As a result, he attracted a diverse group. "There was no master plan other than the file itself," recalled John Collier, who was hired in 1941. "The requirements made of photographers going into the field were so completely loose that the end product[s] were incomparable. No one photographer ever brought back a similar product from any of the others."[50]

Nothing better illustrates the diversity of technique and style within the photography project than the work of Walker Evans. Rothstein's previous experience had been confined to work on university publications and salon competitions. Mydans's work had been in journalism. Evans, on the other hand, was an established artist. As Hank O'Neil writes, he "set the standards of perfection for the others." Working primarily with a large and comparatively awkward view camera, Evans sought to make images that transcended his subjects, that went beyond "the moment in reality": "It's as though there's a wonderful secret in a certain place, and I can capture it. Only I can do it at this moment, only this moment and only me."[51]

In the fall of 1935, Stryker gained the services of the artist, Ben Shahn, who would, like Evans, have a significant impact upon the aesthetic evolution of the photography project. Shahn had been introduced to photography by Evans when the two were roommates in New York City, but Shahn was not primarily a photographer. He had been hired to work in the Special Skills Division as a painter and lithographer. Shahn used his camera to record the people and places he later used as subjects of his paintings and drawings. Shortly after joining the agency, he was sent on an extended trip to the South. He made many photographs along the way, though he intended to use them only as pictorial reminders. Eventually, however, Stryker saw Shahn's images and asked that they be included in the file.

Unlike Evans, who was opposed to the use of his images for political purposes, Shahn urged that the photographs in the Historical Section files be used to promote social and economic reforms. For Shahn, propaganda was not necessarily an evil. "We had only one purpose," he said, "a moral one." His work for the Resettlement Administration was created not to satisfy some ephemeral aesthetic hunger but ultimately to change things. "I am a social painter or photographer," he said in 1946. "I paint or photograph for two reasons: either because I like certain events, things or people with great intensity or because I dislike others with equal intensity." [52]

Early in the fall of 1935 another photographer who believed in the power of photographs to act as catalysts of social reform joined Stryker's staff. Dorothea Lange was the first female photographer to be hired by Stryker and the first from the West Coast. She had been documenting the lives of the poor and unemployed in California since the depression had begun, and in the late summer of 1935 she sent a portfolio of her work to Stryker. Shahn

was in the office when the images arrived. "This was a revelation," he said, "what this woman was doing."[53]

By the winter of 1935, Stryker's small staff of photographers was out on the road, sending work back to Washington, and the file began to take shape. At first, Stryker was amazed at the quality of the work. "I expected competence," he wrote later. "I did not expect to be shocked at what began to come across my desk. The first three men who went out—Carl Mydans, Walker Evans and Ben Shahn—began sending in some astounding stuff that first fall, about the same time that I saw the great work Dorothea Lange was doing in California. . . . Then Arthur Rothstein, who had set up the lab, started taking pictures. Every day was for me an education and a revelation."[54]

Stryker and his staff in Washington worked hard to ensure that the project would not become a routine public relations unit or some kind of fancy quasi-governmental photo agency that made and disseminated pictures of the movers and shakers in Washington. The photographers and their boss shared a commitment to the documentary tradition. "There was a feeling," said Rothstein, "that you were in on something new and exciting, a missionary sense of dedication to this project, of making the world a better place to live in."[55]

Their belief in the documentary idea did not lead to a placid and harmonious atmosphere within either the Historical Section or the government itself. Stryker was criticized for his failure to produce more utilitarian photographs for the other divisions of the RA and FSA. There seemed to be no end to requests for images of happy resettlement clients in their spanking new villages. And there was constant carping from Congress and certain areas of the federal bureaucracy about the waste involved in the photography project. In 1936, for example, there were vociferous complaints about the extravagance of the RA's annual report, which was prepared by Stryker. "The RA has introduced a fresh note into governmental printing," the editors of the *Cincinnati Times* wrote with undisguised sarcasm. "Though penny-pinchers may grumble about extravagance, your true book lovers in Congress will be delighted to add this choice volume to their shelves."[56]

Moreover, there was occasional friction between Stryker and his staff photographers. Ben Shahn's wife pointed out that "most of the photographers were considerably more sophisticated in the visual sense than was Roy Stryker. . . . He was thus the target of constant criticism, of complaints." Shahn and others considered Stryker a vandal for destroying negatives that he felt should not be in the file (he "killed" approximately 100,000 negatives with the use of a hole-punch). Dorothea Lange complained bitterly about Stryker's refusal to let her keep her negatives in California, and Evans felt that only he should be allowed to make prints from his negatives. Despite the complaints, however, the Historical Section began to function smoothly, with a sense of what had to be done and how to do it.[57]

Stryker's desire that the file be more than a visual collection of new government projects was clear from the beginning. He was determined to

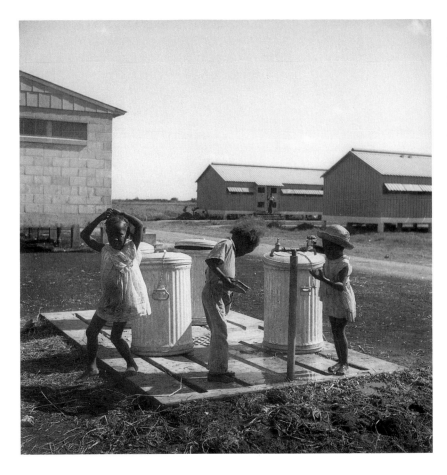

Belle Glade. June 1940. Running water and garbage and refuse disposal cans are placed at the head of each shelter unit division at the Okeechobee Migratory Labor Camp, a Farm Security Administration project.

LC-USF34-54232-E

build a visual history of the United States. Paul Vanderbilt, his assistant, wrote that the images produced on various assignments were only the means to an end. The "file is like a stockroom of parts, not the assembled, useful machine; like a menu, not a well-balanced meal," he said. In the end, the photographs would comprise a gigantic, varied "reference tool to be used in the making of books and other persuasive devices." Stryker and his photographers never really deviated from the underlying goal of the project—to produce what Bernarda Shahn called the "stark presentation of actual conditions, the wordless, statistics-less, visual, inescapable truth."[58]

Eventually, Stryker concluded that the photography unit would have to function in two ways. Photographers would make the pictures deemed necessary by the government—routine images of installations and programs. But their more important task was to produce images that would constitute a social documentation of the times. "Most of what the photographers had to do to stay on the payroll," wrote Stryker, "was routine stuff showing what a good job the agencies were doing out in the field." Having satisfied the needs of the bureaucracy, however, the photographers could throw in "a day here, a day there, to get what history has proved to be the guts of the project."[59]

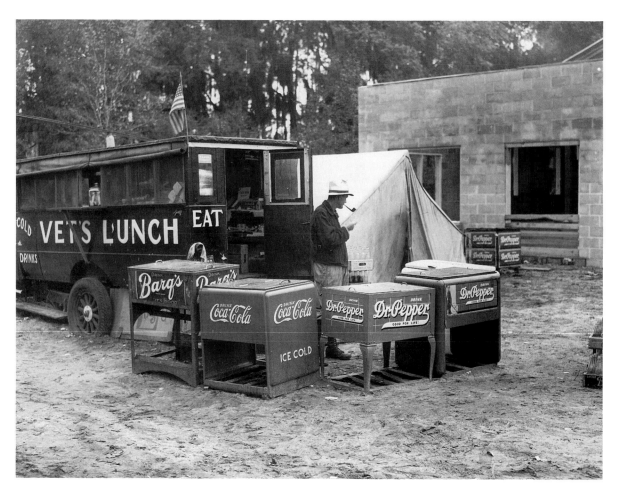

20 • Marion Post Wolcott

Starke. December 1940. A lunch car in front of a pine grove where construction workers are camped in trailers, tents and homemade huts. A laundry building is being constructed at the right.

LC-USF34-56683-D

This policy of balancing photographic coverage can be seen in the work produced in Florida, which included photographs of the resort areas as well as the agricultural districts. Especially in the later years of the project, photographers turned to subjects such as tourism, small-town life, and even the life-styles of the middle class and well-to-do. Doing so, however, was never easy. In a letter written to Stryker from Louisville in July 1940, after an extended trip through Florida, photographer Marion Post wrote that, although poor people rarely "object too strenuously" to having their pictures taken, "these prosperous farmers and 'middle clawses'—they will have none of it. They are all 'agin' the government and the agricultural program and much of the FSA."[60]

Tugwell supported Stryker's twofold purpose for the photography project. He knew that to persuade Americans of the necessity and effectiveness of the RA's programs he would have to do more than show them a series of bland illustrations of government projects. He needed hard evidence that described the deplorable conditions in the countryside, the plight of the people and the land. According to the FSA writer Mark Adams, Tugwell was "disillusioned with the effectiveness of the printed word, unaccompanied by

supporting documents," and so he turned to the media, particularly to "the unimpeachable integrity of the photograph," as a method of "describing conditions which he believed deserved the attention of the public." For Stryker, the plan would be to compile photographs that could be used to support Tugwell's reforms. The better the photographs he produced, the more likely the support from the top.[61]

In the Resettlement and Farm Security administrations, photographs that were used effectively as government publicity often doubled as works of art. "The subjects of land and people," wrote James McCamy, an expert in the field of government publicity, "offer the creative photographer an opportunity to use his camera as a dramatic but accurate instrument of reporting." The twenty or thirty "great" photographs in the file have now achieved the status of icons; they are, for many Americans, the heart and soul of the FSA photography project. But in the 1930s, what counted most was the way in which the entire body of pictures was used. Stryker and his photographers were not working in an artistic vacuum or collecting pictures merely for the edification of posterity. The goal was always to communicate with a mass

21 ▪ Marion Post Wolcott

Belle Glade. June 1940. An aerial view of the Okeechobee Migratory Labor Camp, a Farm Security Administration project.

LC-USF34-54150-D

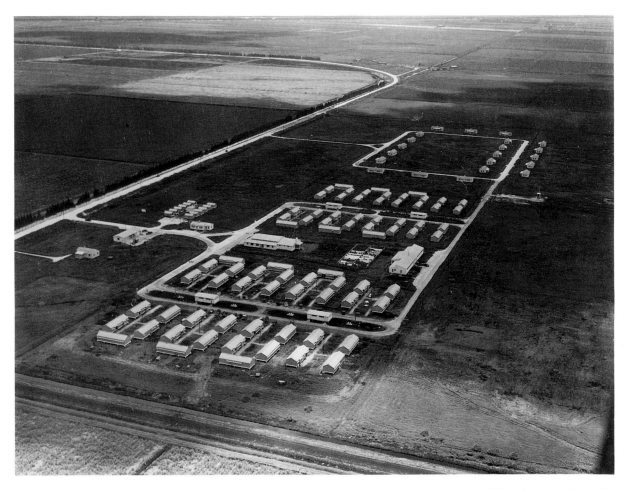

audience, to act, as Stryker wrote, as a "press agent of the underprivileged."[62]

The staff of the Historical Section made sure that the images being produced found their way onto the printed page. Newspapers and magazines were encouraged to use RA and FSA photographs, always without charge. In time, some of the images became famous. "There was a tendency to use the same pictures over and over again," according to Tugwell. "The newspapermen would come in and they were always in such a hurry." Rather than painstakingly sift through hundreds, even thousands of pictures, they simply requested certain images that they had seen elsewhere. Those published most often, said Tugwell, became symbols of the Great Depression in America.[63]

FSA photographer John Collier believed that the real value of the photography project lay not so much in the best-known photographs in the file but in the vast number of undramatic images that comprise a collective portrait of America. In fact, he and Stryker quarreled on this point. Collier felt that Stryker too often used the same few photographs to represent the work of the Historical Section. His view of the file was broader and considerably

22 ▪ Marion Post Wolcott

Canal Point (vicinity). January 1941. Living quarters, store and "juke joint" for migratory laborers.

LC-USF34-57317-D

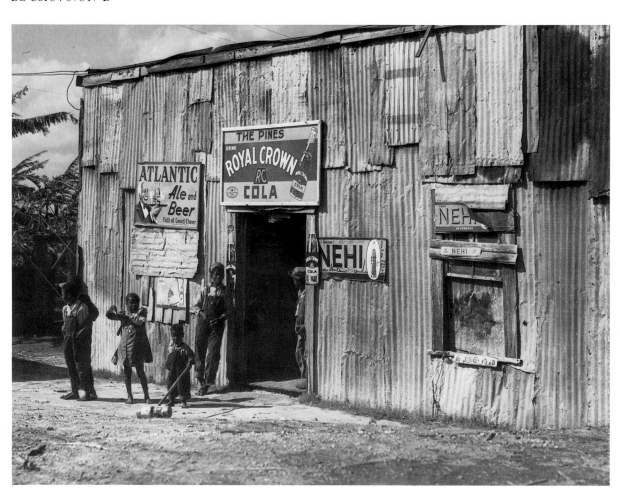

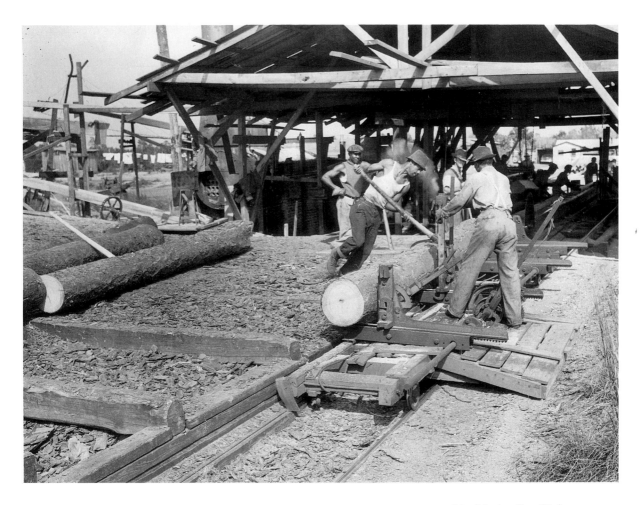

more democratic. In a letter to Anthony Caruso, curator of photography at the Brooklyn Museum, Collier wrote, "It would be easy to throw together a show of the great Langes, Lees, Rothsteins and Vachons, but it must be remembered that each and every one of the FSA photographers contributed to the file, . . . and for every great Lange there are as many great but unknown works of other photographers, buried in the tremendous wealth of [the] material."[64]

Although Stryker's working rationale for the Historical Section was free of rigid stylistic requirements, he did insist that his photographers produce technically flawless work that was informed by a profound understanding of the subject. "Let me emphasize that the photographer must master the technical problems of photography before he can maintain a position in this field, and what is more important, he must recognize that photography is a product of the intellect rather than a product of mechanical skill."[65]

No story better illustrates the importance of "an educated eye" in FSA work than Carl Mydans's memory of his first encounter with Roy Stryker as educator: "I remember the first time I was going off on a story for Stryker's section. My assignment was to go to the South and 'do cotton.' I put my

23 ▪ Marion Post Wolcott

Childs. January 1939. Men working at a sawmill.

LC-USF34-50560-D

cameras together, drew my film, got my itinerary and came in to see Roy and tell him I was on my way. He greeted me, wished me luck and then struck with a sudden thought said, 'By the way, what do you know about cotton?' I said, 'Not very much.' " A few more probing questions convinced Stryker that Mydans was unprepared. He ordered that Mydans's trip to the South be postponed. He and Mydans spent the rest of that day talking about the cotton industry. They "talked about cotton as an agricultural product, the history of cotton in the South, what cotton did to the history of the U.S.A., and how it affected areas outside the U.S.A. By the end of that evening," said Mydans, "I was ready to go off and photograph cotton!"[66]

Stryker often sent his photographers elaborate lists of recommended and required readings. He believed that their main job was to educate the American people, and he would make sure that the educators knew what they were talking about. When either their captions or photographs demonstrated a lack of understanding of agricultural life, Stryker, who had been raised on a farm, was quick to point out the errors. "I am sending you . . . a couple of photographs on which I wish you would check the captions," wrote Stryker to Lange in 1937. "The captions [have] reference to plowing. I do not believe this is correct. What they are doing there is making furrows for irrigation. In Colorado, we would call this marking."[67]

This emphasis on careful preparation and a thorough knowledge of subject matter was in part politically motivated. Given the occasional reluctance of Congress to provide full funding of all of Roosevelt's programs, and the hostility of Republicans toward anything that might be construed as propaganda for the New Deal, Stryker's collection of images and information had to be beyond reproach. Photographers were given reading assignments as well as long "shooting scripts" that contained numerous suggestions for pictures. "Get the picture of the stores in which . . . people have to shop [and] the type of goods on the shelves," Stryker wrote to Russell Lee in Michigan. And watch for "families on the move with their meager goods piled on trucks or wagons."[68]

■ ■ ■ ■

From 1937 to the demise of the photography project in 1943, enormous changes took place in the social, political, and economic landscapes of the country. The working rationale for the project, however, remained the same: photographers were expected to go into the field armed with an understanding of their subject matter and well versed in photographic techniques. "In order for the Farm Security Administration photographers to do their camera reporting they must be something of sociologists, economists, historians," Stryker said in 1940. "That they be expert camera craftsmen is taken for granted. That they have a good general background coupled with the faculty for acquiring a working knowledge of a variety of subjects is essential."[69]

Though reluctant to admit it, Stryker was certainly aware of the propaganda aspects of his job. "It didn't take long to realize that photographs of

the immigrants [and] the sharecroppers were a useful tool for the Information people," he wrote to Robert Doherty. "My sense of P.R. . . . grew rapidly. And we were succeeding with our pictures . . . to a surprising degree." But this was a time when the excesses of government-sponsored publicity campaigns in Russia and Germany were reviled in the American press and a time when some critics accused the New Dealers of using the same tactics as Communists and Nazis. Carlisle Bargeron, for example, described Washington, D.C., as "the propaganda factory for the nation," adding that "the situation has been so one-sided that the New Dealers have had pretty much the full run of the so-called manufactured news."[70]

Stryker willingly accepted the administration's need for photographs that illustrated the various aspects of FDR's farm program. His letters to his photographers contain numerous requests for specific images that could be used to advertise the RA. "We need to vary the diet in some of our exhibits . . . by showing some western poverty," Stryker told Dorothea Lange in 1936. "Do not forget that we need some of the rural slums type of thing." He noted in the same letter that Tugwell "would be very appreciative of photographs" that could be used as "illustrative material for some things which the Department of Agriculture is working on." Later that year he explained to Rothstein that "isolated schoolhouses and roads serving a limited number of people are very expensive items for the taxpayers of any county to maintain. This offers one of the best arguments for Resettlement," he said, and "we need pictures to illustrate this situation."[71]

If Stryker's job was, at least in part, to persuade and to publicize, at least he would do so with honest, well-informed images. Photographers were warned not to manipulate their subjects in order to create a sense of drama, and the pictures were almost always printed without cropping or retouching. This combination of a straightforward approach with political and social argument is the essence of what is now known as social documentary photography. "The most effective documentary photographs are those that convince their observers with such compelling, persuading truth that they are moved to action," wrote Rothstein. The Historical Section "used the camera most extensively to interpret and comment."[72]

By its nature, 1930s documentary photography precluded a neat escape into an artistic ivory tower. Stryker's photographers were involved in the events of the day; they could not avoid influencing public policy, even if, like Walker Evans, they wanted to do so. The writer and critic Elizabeth McCausland explained, "The crisis of world wide depression, of imminent fascism and war" made it impossible for the artist to "go forward on the old basis." Because of the times, "he had to acquaint himself with poverty, unemployment, starvation, slums, eviction, relief, [and] picket lines." Stryker and his staff did precisely this. Their purpose was to acquaint the country with the facts of depression and the means to recovery.[73]

On December 31, 1936, the Resettlement Administration was transformed from its status as an independent agency within the bureaucracy to that of an agency within the massive Department of Agriculture. On Septem-

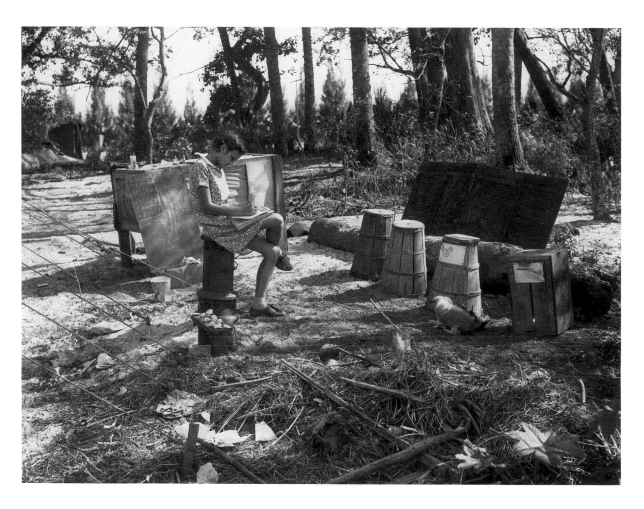

24 ▪ Marion Post Wolcott

Canal Point vicinity. [No date.] A migratory packing house worker's child playing school.

LC-USF34-51172-D

ber 1, 1937, the Bankhead-Jones Farm Tenancy Act gave the new entity legal status and changed its name to the now familiar Farm Security Administration. Most important, when the RA was transferred to the Department of Agriculture, Rexford Tugwell resigned as director. Since a good deal of the criticism of the RA's programs had been directed specifically at Tugwell, his absence from the new agency tended to lessen the hostility of the critics.

Under Tugwell, the aim of the Resettlement Administration had been the complete overhaul of the agricultural community. He believed that the depression could be used as a catalyst to promote and organize a radical transformation of farm life and that massive federal intervention could finally eradicate chronic rural poverty. Although there was considerable public support for federal aid to the rural poor, there remained an extremely vocal opposition to Tugwell's plans, especially within the agricultural community. Tugwell's ideas were far too radical, if not actually un-American, for the power structure in agriculture, which consisted of federal and state extension services, land grant colleges of agriculture, and the American Farm Bureau Federation. He was seen as an academic interloper, a nonagri-

culturalist who would destroy forever the rural status quo. Moreover, the bureaucratic waste and inefficiency that dogged several of the early programs of the RA were seen as portents of a Tugwellian future that threatened American individualism and local control.

Tugwell explained that his decision to leave the government was a response to the conservative powers in agriculture, especially in the South, who systematically undermined federal programs that upset what was essentially a feudal land system. "From this time on," he wrote, "the good intentions of the Resettlement Administration . . . were understood to have been abandoned. This agency was never to have the effect it might have had in reconstructing southern agriculture. The sharecroppers were abandoned to the ancient customs of the landlord system."[74]

With Tugwell gone, life became a little easier for the employees of the FSA, in part because he had attracted so much criticism. According to Calvin Benham ("Beanie") Baldwin, the new director of the FSA, Tugwell "had become . . . the center of controversy in the New Deal, . . . the number one devil, and it wasn't just because of our work in Farm Security. . . . Anyway, Rex decided—he was an extremely conscientious person, very fond of Roosevelt—he had decided that he had become a liability to Roosevelt."[75]

Under Baldwin's direction, the FSA subtly changed the emphasis of its programs from the total eradication of endemic rural poverty to the maintenance of the family farm. Thus, early in 1937, Stryker directed his photographers to broaden their coverage of the rural scene to include more prosperous areas and especially the small towns, a change that would have far-reaching consequences.

First, as the photographers moved away from being single-minded propagandists for an aid program aimed at the most disadvantaged of the rural poor toward a broader documentation of agricultural America, popular support for their activities increased. Moreover, there developed the possibility that Stryker could now build the file into an extensive visual record of American life. A new category of images that Stryker called "Americana" was included in the shooting scripts sent to the photographers. In addition to the usual images of poverty in the agricultural sector and those made of governmental programs and installations, Stryker called for more pictures of ordinary, middle-class Americans.

At the same time that the leadership of the FSA was altering the emphasis of the agency's programs, the makeup of the photographic unit was also changing. During the years 1937 and 1938, most of the members of the original group left. There is no evidence to suggest that Stryker made a conscious effort to work with a new group of photographers after Resettlement became Farm Security. But the fact remains that for a time after 1939, only Arthur Rothstein remained from the original five.

Carl Mydans was the first to go. Then, in the summer of 1936, Walker Evans took a leave of absence to work with his friend James Agee on a project for *Fortune* magazine. Stryker agreed to the leave with the stipulation that all the negatives Evans produced would become the property of the

Historical Section. The work of Evans and Agee in Hale County, Alabama, was never actually used by *Fortune*. The two men collaborated instead on a book, *Let Us Now Praise Famous Men,* that is rightly considered an American classic.

For both Evans and Stryker, the leave of absence was a welcome relief. Stryker had become increasingly impatient with Evans's refusal to adapt to the needs of the bureaucracy. His output, though consistently of high quality, was meager. He was uninterested in the needs of the RA and unwilling to take routine photographs of government projects, and he expressed unending contempt for the Washington bureaucracy. For his part, Evans felt that Stryker was blind to his needs as an artist. "Stryker did not understand that a photograph might be something more than just an item to file away. He missed the point of the eye," said Evans. "Stryker did not have any idea what an artist was and it was unfortunate that he had one like me around. I was excessively independent by temperament and had a hard time with him because of this. Stryker was shrewd enough to make use of the talent I had, but we were born to clash."[76]

Evans left the FSA in September 1937. One month later Stryker fired Dorothea Lange, for the second but not the last time. Budget personnel in Washington had always chided Stryker for his insistence on maintaining a photographic operation on the West Coast. Lange insisted on maintaining a

25 ▪ Marion Post Wolcott

Plant City. March 1939. A strawberry festival and carnival.

LC-USF33-30477-M5

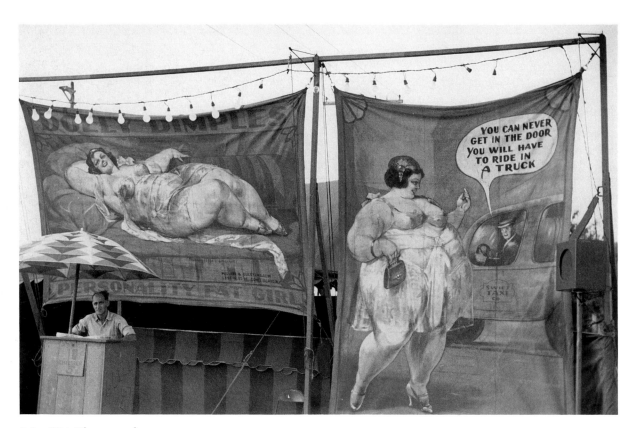

darkroom to process her negatives and prints. When money got tight, Lange's operation was usually the first to feel the squeeze. Lange was let go for the third and final time in 1939. As with Evans, it appears that Stryker resented Lange's frequent demands for special treatment. Although he greatly admired her work and was satisfied with her level of productivity, he was uncomfortable with her inability to function easily within the bureaucracy. "We are very sorry to lose her," Stryker wrote to Grace Falke, "because she does turn out such excellent work. Every time she has caused so much confusion I have had to forgive her when I saw the work she sent in."[77]

By 1938, Ben Shahn was gone, too, though he had not officially been a member of Stryker's staff. His salary had been paid by the Special Skills Division, but he allowed Stryker the use of his images. Because he spent most of his time in Washington (he made long trips to the South in 1935 and 1937 and covered parts of the Midwest in 1938) Shahn produced relatively few images for the FSA, but his pictures were prized by the staff. Stryker valued Shahn not only for his photographs but also for his help in establishing a working rationale for the project. Shahn felt that the photographs could be used effectively as a tool to promote social change, and he encouraged Stryker to use them as propaganda. Thus at an early staff meeting when Stryker praised a photograph of soil erosion for its clarity and sharpness, Shahn demurred. "You're not going to move anybody with this eroded soil," he told Stryker, "but the effect this eroded soil has on a kid who looks starved, this is going to move people."[78]

Throughout most of 1937 and 1938, the years of the "Roosevelt Recession," Stryker's budget was limited and his staff consisted of just two photographers, Rothstein and Russell Lee, who was hired late in 1936 to replace Carl Mydans. By the end of 1938, however, funding was increased and Stryker rehired Lange and hired Marion Post (after her marriage she added her husband's name, Wolcott, to her own), a staff photographer at the *Philadelphia Evening Bulletin*. Stryker learned of Post's work through photographer Paul Strand, who wrote to him in June 1938, "She is a young photographer of considerable experience who has made a number of very good photographs on social themes in the South and elsewhere."

Post's images added a new dimension to the work of the Historical Section. More than anyone else on the staff, she was able to show the disparity between the rich and the poor. In Florida, according to historian Robert E. Snyder, Post "was excited by the photographic possibilities of contrasting the affluence some people enjoyed in resorts along the white sand beaches with the wrenching poverty experienced only a few miles away in the migrant camps."[79]

The range of Post's work in Florida can be seen in a series of pictures she produced early in 1941 in the juke joints that catered to local farm workers and migrants near Belle Glade. The jukes (also spelled jooks) were part dancehall and part bar. Along the thirty miles of highway across the northeast corner of Palm Beach County were more than a hundred joints, with names like Little Cuba, The Jeep, Vinegar Bend, and Heastie's Hot Spa.

In an article in *The Saturday Evening Post* of April 26, 1941, which was illustrated in part by Post's photographs, Theodore Pratt described Florida as the home of the juke and pointed out that the greatest concentration of such places "is less than an hour's drive from the luxury of Palm Beach." The frontier-like violence of the region was, for Pratt, a product of "the most outrageous kind of farming practiced in America." For migrants living in abject poverty, the jooks offered a welcome, if temporary, escape.[80]

In 1938, Stryker gained the services of another photographer, John Vachon. When he had first joined the agency three years earlier, Vachon had neither experience with nor interest in photography. His job as junior file clerk was to stamp the backs of the images with the photographers' names and copy the captions. In time the pictures began to pique his interest, however. Vachon asked if he could try his hand at photography, and Stryker, ever the opportunist, gave his approval. Stryker was also open to the possibility of incorporating into the file photographs by persons outside the staff. Perhaps the most famous of these photographers was Gordon Parks, who interned as a photographer with the Historical Section courtesy of a Julius Rosenwald Fellowship in 1942.[81]

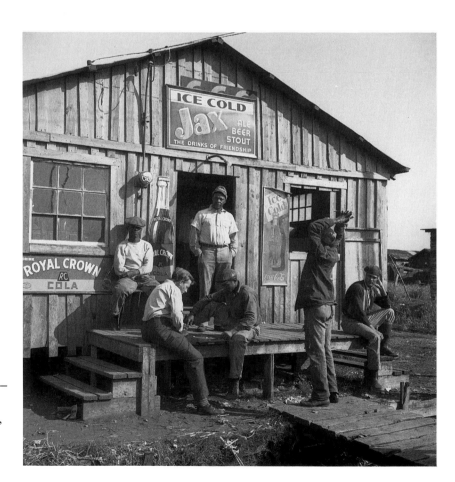

26 ▪ Marion Post Wolcott

Belle Glade. February 1941. Migratory laborers playing checkers outside of a "juke joint" during a slack season.

LC-USF34-57261-E

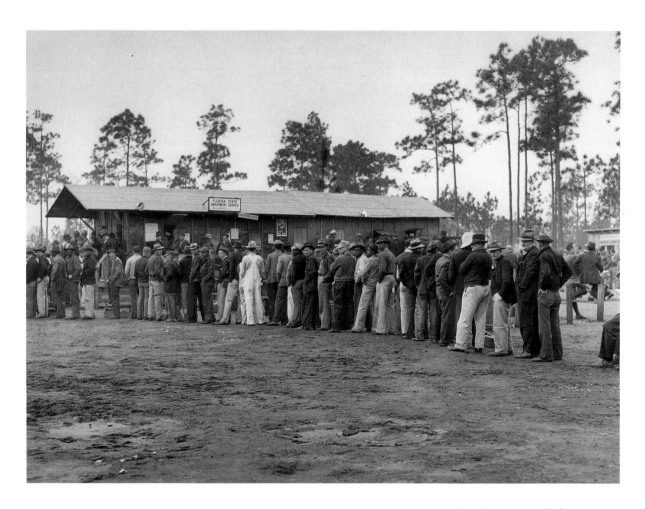

Vachon began working on the weekends around Washington, D.C. Many of his photographs, he recalled, "were accorded the consummate honor: they were added to the file."[82] In October 1938, Vachon was given his first long, in-depth assignment—a trip to the Midwest. Thereafter, he worked nearly full-time as a photographer, although he was not officially employed as such until 1940.

When Rothstein left the FSA in 1940 to join the staff of *Look* magazine, Stryker filled the vacancy with Jack Delano, who had just completed a tour with the Federal Arts Project. Delano had studied at the Pennsylvania Academy of Fine Arts and had been awarded a Cresson Traveling Fellowship in 1936, which had enabled him to photograph in Europe. Like Post, he came to the attention of Stryker through Paul Strand.

By 1941 the inevitability of war began to dominate the thinking of most Americans, and the FSA work reflected the new mood. "I am very anxious that we get additional pictures of the soldier life around the towns near big encampments," Stryker wrote Delano. And in a joint letter to Lee and Delano, he explained the new emphasis on urban photographs: "Our emphasis at this particular time on industrial centers is simply in keeping with

27 ▪ Marion Post Wolcott

Starke. December 1940. Carpenters and construction workers waiting outside the state employment office, trying to get jobs at Camp Blanding.

LC-USF34-56742-D

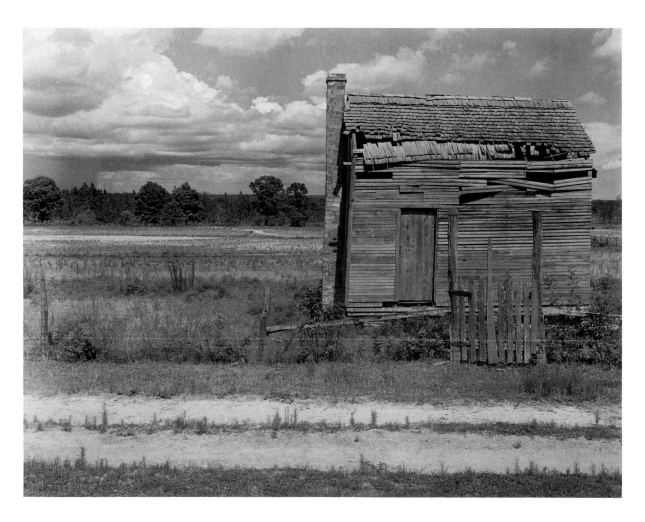

28 ▪ John Collier

Escambia farms vicinity. June 1942. Behind this skeleton of a sharecropper's house bordering the Escambia farms are the reasons for its abandonment: poor soil, badly eroded.

LC-USF34-83739-C

the shift which is taking place in the country," he said. People who had been unemployed for years were suddenly finding jobs. Even the migrant situation had changed. Stryker was determined to record the changes in the country.[83]

Some of the assignments were pure propaganda. With war an inevitability, Stryker and others in the FSA believed that it was important to make and distribute photographs that described a healthy, powerful America. "Emphasize the idea of abundance—the 'horn of plenty' and pour maple syrup over it," he told Delano in 1940. "I know your damned photographer's soul writhes, but to hell with it. Do you think I give a damn about a photographer's soul with Hitler at our doorstep?"[84]

In order to tell the story of the effects of war on the civilian population, Stryker decided to increase his staff. He hired John Collier, Jr., in September 1941, partly on the recommendation of Dorothea Lange. Like so many of the other photographers who participated, Collier had a background in fine art, having studied painting at the California School of Fine Arts under the tutelage of Maynard Dixon, Lange's first husband. His long friendship with Lange and Dixon led to a decision to pursue photography, a medium that he

felt could produce powerful visual documents without succumbing to decadent artiness.

■ ■ ■ ■

In the 1939 edition of the *U.S. Camera Annual,* Edward Steichen defended the work of Stryker's photographers, which was attacked in Congress as being wasteful and politically motivated: "Pictures in themselves are very rarely propaganda. It is the use that is made of pictures that make them propaganda." Stryker, who always refused to admit that any work produced at the FSA was propagandistic, was adept at ensuring that the images produced by his photographers were widely used. The honest photograph, he said, "brings certain subjects to people's attentions more powerfully than a group of words"; as an educational and persuasive device, it is unequaled.[85]

The most willing user of FSA photographs was the government itself. Stryker supplied illustrations for all manner of federal publications, both within and outside of the Department of Agriculture. As a ready supplier of good, sharp images, Stryker undoubtedly built up goodwill in the bureaucracy. But the photographs that were used in government publications did not reach nearly enough people to be considered truly effective, either as education or as propaganda.

To reach the maximum number of people with the message of the FSA's programs, Stryker turned to mass circulation magazines and newspapers. Outlets such as *Life, Look,* and the rotogravure pages of major newspapers assured that the images were seen by a national audience. The larger the audience, the more people could be persuaded that the agency's programs were worthwhile. Several smaller, special-interest publications such as *Survey Graphic* and the photography magazines also were willing users of FSA images, thereby helping to create a favorable public response.

As the work of the photographers became better known, the images were published as book illustrations. The first was *Land of the Free* by Archibald MacLeish, a long poem set to pictures. MacLeish said that the original purpose had been "to write some sort of text to which these photographs might serve as commentary." But he found that "so great was the power and the stubborn inward livingness of these . . . documents" that in the end his words served as accompaniment to the images. Stryker, who worked closely with MacLeish on the selection of the images, was enthusiastic about their use in book form. "We are very busy now working on the material for the MacLeish book," he wrote to Grace Falke. "I believe this will be a worthwhile proposition. It certainly will be a good use for RA pictures."[86]

Several other important collections of FSA photographs followed the publication of *Land of the Free.* Some months later in 1938, for instance, the Museum of Modern Art published *American Photographs* by Walker Evans, the catalogue of his exhibition. In 1939, Dorothea Lange and Paul Taylor published their visual and prose argument on behalf of the migrants, *An American Exodus.* And in 1941, *Let Us Now Praise Famous Men* was finally

published by Harper's. Although it received wide critical acclaim, it was not particularly successful commercially, for by that time the prospect of war had supplanted the nation's preoccupation with the depression.

The publication of FSA photographs in books, magazines, newspapers, and government handouts served to acquaint Americans with the work of the agency and contributed to the creation of public support. All these outlets had a common drawback, however: Stryker had no control over layout, design, caption material, or editorial policy. It was in the traveling exhibitions of photographs sponsored by the FSA that Stryker had total control of presentation. These shows were perfectly suited to the publicity needs of the government. According to Werner Severin, "they were a natural outgrowth of Tugwell's idea of reaching the public directly, and they varied greatly depending upon where and to whom they were to be shown."[87] For Stryker, they were the ideal means to tell the message of the FSA and at the same time display the creative work of his photographers.

While hard at work on a major exhibition of FSA images at the Museum of Science and Industry in New York City, Stryker noted that the show would be good for the Historical Section. He enthusiastically reported, "We are going to get publicity in every paper in New York and also get a lot of attention from the various photographic clubs. The big exhibit will have FSA plastered all over it."[88]

Colleges and universities throughout the country used the FSA exhibits, as did many regional offices of the agency and art museums. The approbation of the art world perfectly suited Stryker's purposes, for therein was the ideal blending of the still image as art and propaganda, as historical document and visual persuasion.

Few have argued about the artistic value of the work produced for the Historical Section. But the use of the images by an agency of the federal government to further its own cause was controversial during the life of the program and remains so today. In 1940, Hartley Howe defended the marriage of art and propaganda in an article for *Survey Graphic*. Attacks on Stryker's project, he said, "centered around charges that it is one-sided propaganda for the New Deal." Howe admitted that one might legitimately ask how far the government should go in advertising its own programs. But he added that "government-sponsored publicity which is accurate, and which tells about policies and programs rather than individuals and parties, is not only harmless but desirable. Certainly, FSA photographs come well within this category."[89] Stryker's unit never sought to idealize Roosevelt or other leaders of the Democratic party. Their chief function was always to describe the conditions that made government programs necessary. Insofar as the photographers attempted to publicize the good deeds of the Resettlement and Farm Security administrations, their work can be called propaganda. But it was propaganda consisting of documentary images, unmanipulated photographs depicting real life.

More than any other photographer in the FSA group, Dorothea Lange was clear about the persuasive character of her photographs for the govern-

ment. "The harder and more deeply you believe in anything," she said, "the more in a sense you're a propagandist." Conviction, propaganda, and faith were, for her, indistinguishable. "I have never been able to come to the conclusion that it [propaganda] is a bad word."[90]

World War II signaled the end of the Farm Security Administration. The war against chronic rural poverty took a back seat to global conflict as the resources of the nation were channeled into the struggle against fascism. Even before America was actively engaged, various relief efforts were transformed into defense programs. By the end of 1941, one in three WPA employees was involved in projects related in some way to national defense. And shortly after the attack on Pearl Harbor, Stryker told Delano that from now on "we are going to be very busy doing our share of war activities." He was not at all sure about the exact nature of those activities, but he assured Delano that everyone would have to "work long hours and very hard. After all we are a service agency."[91]

Although some FSA officials argued that the agency could best assist in the war effort by continuing to aid needy farmers, thereby increasing the nation's food supply, there was a consensus in Washington that most domestic relief efforts would have to be drastically reduced. The quest for social justice and economic equality would have to wait. Oren Stephens, long a supporter of the FSA, nevertheless wrote in 1943 that "resettlement and rehabilitation as usual must be dropped completely, for the duration . . . for victory on the battlefield must come first."[92] In September 1942, Secretary of Agriculture Claude Wickard ordered that the entire department, FSA included, be oriented to the war effort. Increasing the food supply was the highest priority; programs dealing with soil conservation, rehabilitation, and resettlement were shunted aside.

Instead of providing low-cost housing for migrants, the FSA turned its attention to the problem of housing thousands of new workers in the burgeoning defense industries. Large tracts of land that were originally intended to be used as resettlement villages for displaced farm families were used instead for more immediate, and in some cases, questionable purposes. Military installations sprang up on some of the land, but in California two large parcels of FSA-purchased property were used as internment camps for Americans of Japanese descent.

The decision to dispense with the war against rural poverty was made by the president himself. His reasons for so doing were partly financial: the budget could only handle one war at a time. But there was more to the president's decision than simple bottom-line determinism. Just as Roosevelt had sought to unify the nation's energies in the struggle against economic disaster during the early days of the depression, now he did the same in the struggle against totalitarianism. According to Tugwell, FDR's decision to scuttle the FSA was made in order to placate the conservatives in Congress. "Roosevelt could get the unity he felt the country must have only by abandoning the New Deal and appeasing the conservatives. It was not to be a New Deal war, . . . it was to be an American war."[93]

The first serious challenge came from the Joint Committee on the Reduction of Nonessential Federal Expenditures, chaired by Senator Harry F. Byrd of Virginia. With the enthusiastic support of the Farm Bureau Federation and the Cotton Council, Senators Byrd and Kenneth McKeller of Tennessee and Congressman Everett Dirksen of Illinois questioned the advisability of spending large sums of money on a relatively small group of poor farmers. "Economy" was the battle cry. Appropriations to the agency were drastically reduced in 1942 and 1943. The rural rehabilitation program was cut by 43 percent, and there were similar reductions in land purchasing, leasing, and cooperative activities. On July 12, 1943, the president signed the so-called death appropriation bill into law, and the leaders and employees of the FSA began to look for other jobs. The agency continued to exist with a tiny staff and little to do until 1946, when President Truman signed the Farmers Home Administration Act. This bill formally abolished the FSA, creating in its stead the Farmers Home Administration (FHA).

It is perhaps fitting that the FSA, an agency that was heavily involved in fighting political battles during its existence, finally died a political death. The long struggle against intractable rural poverty was (and still is) tied to the political climate of the times. Roosevelt, the consummate politician, understood this better than most. The war had finally made the old formulas of the depression years obsolete, and FDR lost little time in distancing himself and his administration from costly domestic programs with only tenuous public support.

Shortly before the drastic budget cuts of 1943, Stryker became convinced that the Historical Section was no longer a viable entity. The photographers were working almost exclusively for the Office of War Information (OWI) as funds for traditional FSA projects dried up. "My thoughts turn a lot these days to what the months ahead hold for us," he wrote to Lange. "I do wish we could have a little more permanence—a little more feeling of security beyond the end of each fiscal year." In September 1942, Stryker told FSA administrator C. B. Baldwin that the only way to save the photography project was to transfer it to OWI. "I think we ought to get out because you are in trouble," Stryker said. "I think we ought to go to the OWI and get out of your hair."[94] With considerable reluctance, Baldwin agreed, and the unit was transferred.

The shift to war work proved to be extremely disappointing for Stryker. The assignments were, for the most part, dull and routine, calling for the production of endless numbers of pure public relations photographs. There was little time or use for the kinds of documentary images for which the Historical Section was famous. "The whole trend in this town is now against the things which we were doing," Stryker complained to Lange just two weeks before he resigned. "I don't think you can really imagine what a dismal atmosphere prevails in our Capitol."[95]

Boring assignments were the least of his problems. Because his photographers did not have civil service status within the government, they were susceptible to the draft, and Stryker was powerless to protect their positions.

And budget cuts continued to exact a heavy toll. By the spring of 1943, Stryker's position was merely custodial. With no photographers on the payroll his job had devolved into that of a picture researcher. He spent his days providing pictures for use by OWI and other agencies from existing negatives within the file. He began making serious plans to quit.

Before leaving, however, he was determined to assure the future of the file. There were those in government who seemed equally determined to see it eradicated. The New York office of OWI's information division was run by a veteran of the Associated Press named Tom Sears. The AP had always disliked Stryker's unit, seeing it as unfair competition (Stryker charged nothing for the use of Historical Section photographs). Sears evidently began looking for ways to eliminate the file altogether. "We feel certain that he would like to come down and pick out parts of the best materials in the file and move [them] to New York," Stryker wrote to his friend Jonathan Daniels, administrative assistant to the president. Eventually, "he will want to break up the whole outfit, get rid of the laboratory and farm out the technical work to private agencies." And Sears was not the only one. Stryker told Daniels that George Lyon, a deputy administrator in OWI, disliked him and would certainly "go out of his way to smash [the] place if for no other reason than to settle some of his personal animosities." Other enemies of the photography project were reported to have contracted a chemical company to remove and melt down the negatives, salvaging the silver, destroying the unnecessary images.[96]

With few allies within the OWI, Stryker appealed directly to the White House. Archibald MacLeish had been appointed Librarian of Congress and was anxious to house the entire collection. He and Stryker agreed that the photographs would thereby remain in the public domain and be easily accessible to anyone who wanted to use them. In another letter to Daniels at the White House, written the same day, Stryker spoke of the consequences of losing the Historical Section work: "Such dismemberment would be fatal, for this is a live, an active record. Out of the America at peace grew the strength of the America at war. The soil is the same soil and the people are the same people." Daniels saw to the necessary details, and the transfer to the Library of Congress was made. Having made sure that his beloved collection would be preserved intact, on October 2, 1943, Stryker resigned his position, citing as reasons "the reduction of the number of photographers, the decrease in the editorial staff, and the curtailment of distribution functions."[97]

Since the demise of the photography project more than four decades ago, the work produced under Stryker's direction has assumed the aura of legend. Many of the photographs have the power to provoke, to persuade, and to inform. Stryker selected his staff with great care. It was no accident that they produced works of art. With considerable prodding from Evans and Lange, he established high aesthetic standards for his photographers. The government needed strong visual images to explain the work of the RA and FSA, and Stryker was adept at eliciting the best from his photographers. But he never admitted that his purpose was propaganda. In the thirties the connota-

tions of the word were entirely nefarious; propaganda was something that Communists and fascists produced, not democrats. Instead, the photographs were said to be documentary. They depicted actual facts, and the approach was straightforward and honest. There was no attempt to mislead or misinform. The pictures spoke the truth.

Under Stryker's direction, the camera was used as an instrument of social science and a medium of communication. Stryker believed, however, that the political usefulness of the photographs never outweighed their potential value as historical documents. What mattered most to him was the possibility of building a visual record of American culture. In this effort he was at least partially successful. As Alan Trachtenberg writes, the FSA file "deserves to be recognized as one of the prime cultural artifacts of the New Deal." The collection, of course, is not unbiased, for photographs inevitably reveal the point of view of the person behind the camera. Nor is the meaning to be gleaned from either individual images or the collection as a whole immutable.[98] As a historical document, however, the file is unequaled; the photographs provide an unique and powerful glimpse at 1930s America, an America that is long gone. "If it is not the single most monumental photographic coverage ever executed, it is certainly the most monumental ever conceived."[99]

The Photographs

*I*n selecting the images included in this work, we have attempted to show the broad range of subjects with which the FSA photographers dealt in Florida. The original captions in the FSA file are included under each photograph. Where appropriate, additional explanatory material is printed in brackets immediately under the FSA captions and Library of Congress negative numbers.

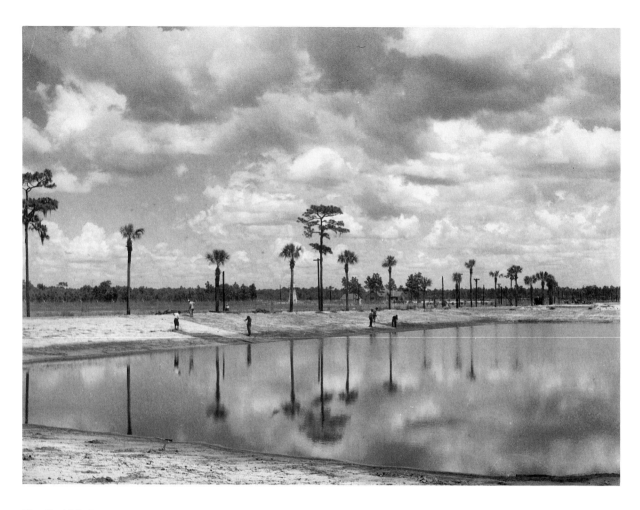

29 ▪ Carl Mydans

Welaka Wildlife and Forest
Conservation Project, Welaka.
June 1936. Preparing banks for
grass planting in one of the ten
two-acre fish-rearing ponds.

LC-USF34-6723-D

[Welaka, a small town on Route 308
just north of the Ocala National Forest
in Putnam County, was the site of the
Florida State Fish Hatchery and Game
Farm, a 2,500-acre complex developed
by the Resettlement Administration in
collaboration with the State Board of
Conservation. Adjacent to the
hatchery were a deer park, a quail
farm, an aviary, and exhibits of native
birds.]

30 ▪ Carl Mydans

Withlacoochee River Agricultural Demonstration Project, near Brooksville. June 1936. Abandoned land and poor pasture.

LC-USF33-663-M5

[Withlacoochee is a Creek Indian name meaning "little great water." The Withlacoochee River rises from the Green Swamp in northern Polk County and flows in a northwesterly direction toward the Gulf of Mexico.]

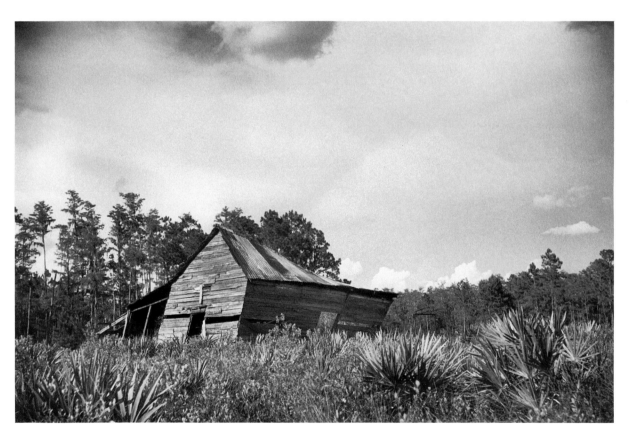

31 ▪ Arthur Rothstein

Belle Glade. January 1937. A
street scene in the Negro section.

LC-USF33-2363-M5

[Belle Glade was built in 1925 but was
almost completely destroyed in the
1928 hurricane. With a population of
only a few thousand by the end of the
depression, it was nonetheless the
commercial center for truck farming
around Lake Okeechobee. Blacks
provided most of the labor force in the
area. A municipal ordinance required
blacks to be off the streets by 10:30
each night; on Saturdays they were
allowed to remain in the downtown
business district until midnight.]

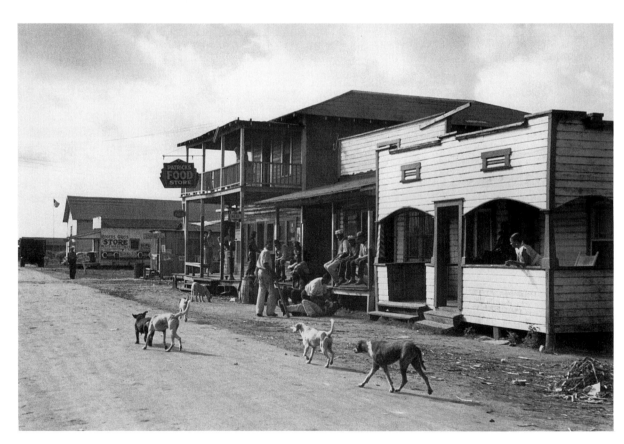

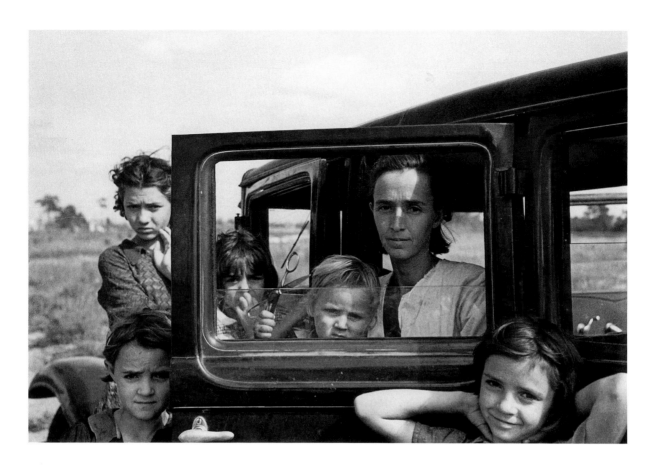

32 ▪ Arthur Rothstein

Winter Haven. January 1937. The
family of a migratory fruit worker
from Tennessee camped in a field
near the packing house.

LC-USF3301-2372-M3

[Migrant workers were attracted to
Winter Haven because of the extensive
citrus groves surrounding the city.
Nine citrus packing houses and three
fruit canneries were in operation in the
city during the late 1930s. Packers
wrapped oranges by hand and placed
them in boxes holding 1.6 bushels. Pay
ranged from four to eight cents a box,
and fast workers willing to work long
hours could make about five dollars a
day.]

Belle Glade. January 1937. A migrant fruit worker, formerly a tenant farmer in Georgia.

LC-USF33-3358-M1

[Although farm tenancy was a major problem throughout the southern states during the depression, it did not manifest itself in the same way in Central Florida, where industrialized farming was dominant. Migrant workers had many of the same problems as tenant farmers, however, including low wages and poor living conditions.]

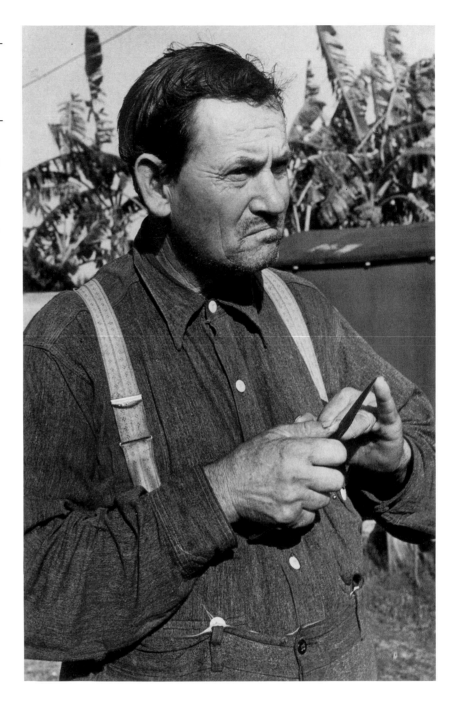

Belle Glade. January 1937. A one-legged medicine man who is encamped with the migrant fruit and vegetable workers.

LC-USF33-2354-M2

[Among many native-born Floridians and seasonal workers, patent medicines, as well as teas and brews made from local plants, were popular and widespread. The patent medicine for malaria usually consisted of a cathartic and quinine.]

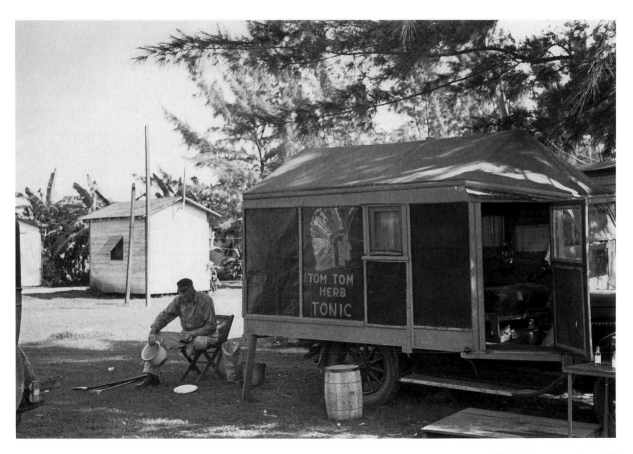

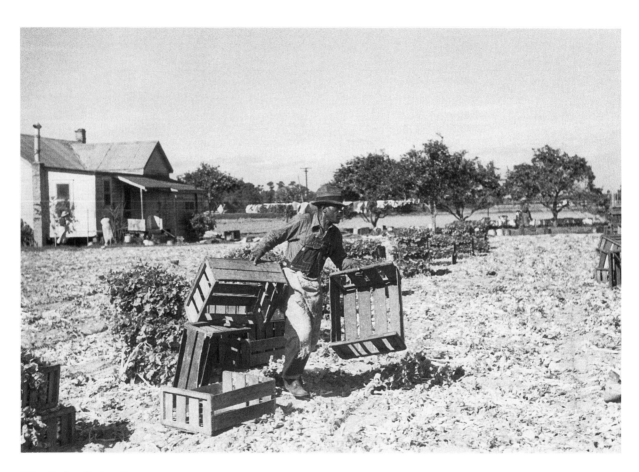

35 ▪ Arthur Rothstein

Sanford. January 1937. Rushing
boxes to the harvester in the celery
field.

LC-USF33-2348-M4

[During the depression, Florida
produced 40 percent of the celery
grown in the country. About 8,000
carloads were shipped from the state
annually, primarily from the area
around Sanford in Seminole County.]

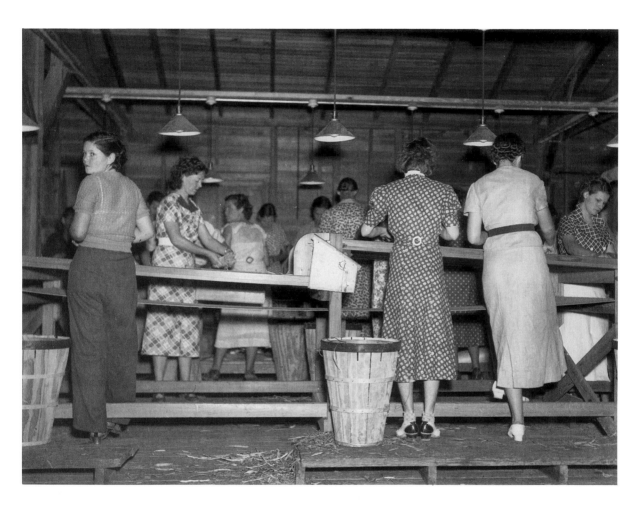

36 ▪ Arthur Rothstein

Deerfield. January 1937. Young
girls grading string beans. Many
of these workers are from
Alabama and Georgia.

LC-USF34-5802-D

[By the end of 1937, Florida was
producing 37,518 boxcar loads of
vegetables a year with a total value of
just over $30 million.]

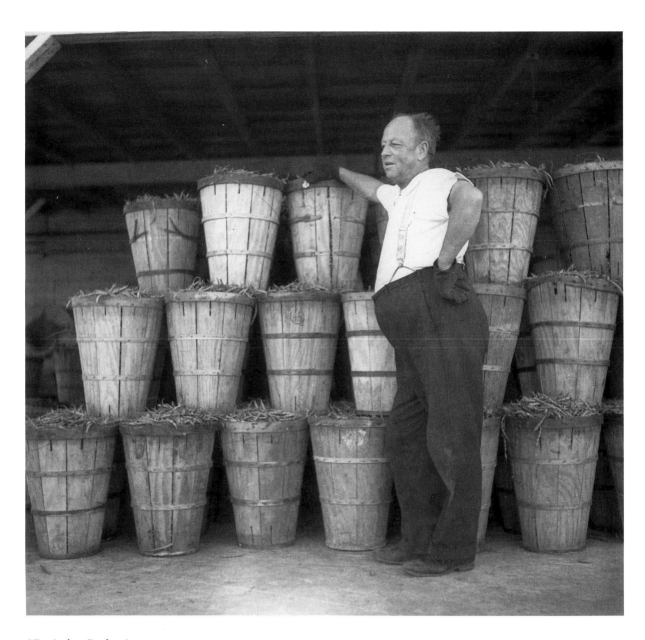

37 ▪ Arthur Rothstein

Dania. January 1937. A foreman
at a canning plant, an Indiana
farmer who originally came to
Florida on a vacation.

LC-USF34-5859-E

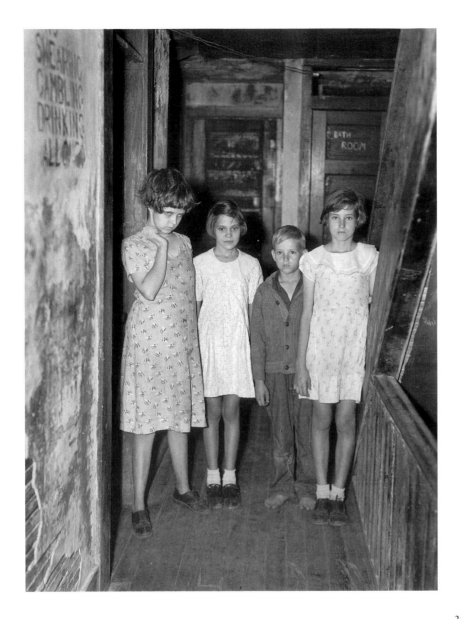

38 ▪ Arthur Rothstein

Winter Haven. January 1937.
Children of citrus workers in the
hallway of an apartment house.

LC-USF34-5795-D

[Citrus production and the demand for
seasonal workers steadily increased
during the depression. In 1929, the
total estimated production was
approximately 8.5 million boxes; ten
years later this number had increased
to 41 million.]

39 ▪ Arthur Rothstein

Winter Haven. January 1937. The
son of a citrus worker.

LC-USF33-2374-M2

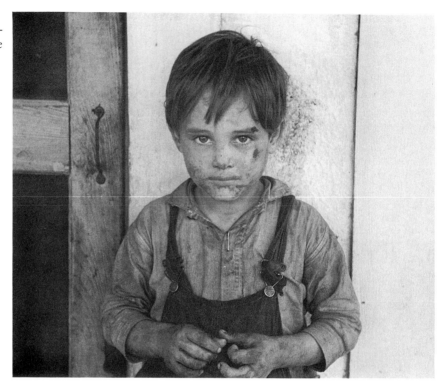

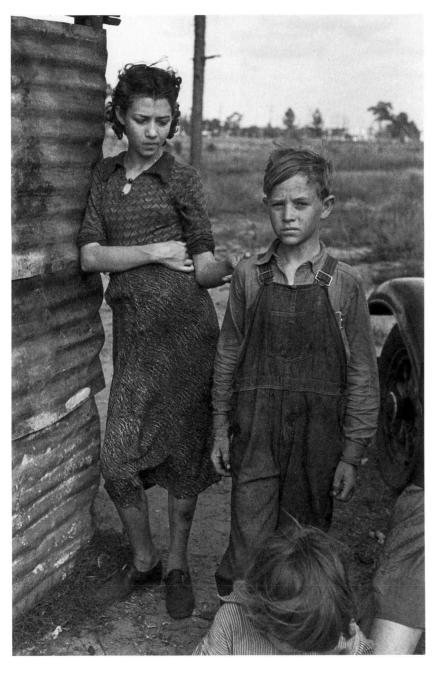

40 ▪ Arthur Rothstein

Winter Haven. January 1937. Part of the family of a migrant fruit worker camping near the packing house.

LC-USF3301-2372-M5

Polk County. January 1937. A
migrant orange picker.

LC-USF33-2380-M2

42 ▪ Arthur Rothstein

Polk County. February 1937. A highway marker.

LC-USF34-5876-E

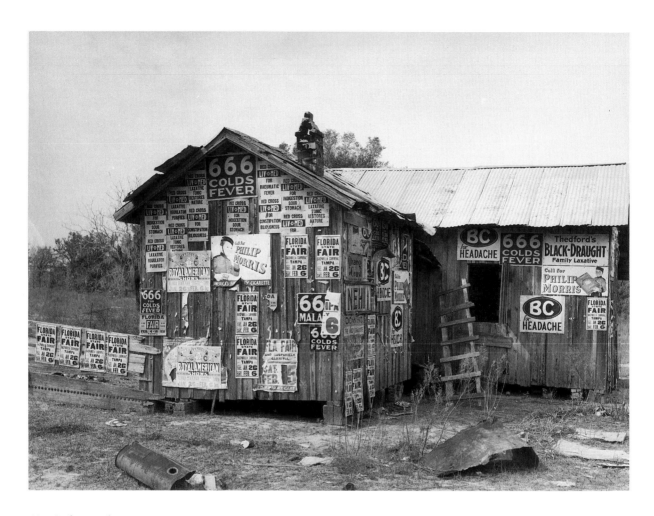

43 ▪ Arthur Rothstein

Withlacoochee Land Use Project.
February 1937. An abandoned
house in the project area.

LC-USF34-25093-D

[Timber resources in Florida had been
ruinously exploited in the decades
preceding the depression. Many areas
were decimated by clear-cutting and
turpentine production. Three-fourths
of the state's virgin timber had been
cut by 1930.]

Careyville. July 1937. Stranded
residents who formerly earned a
livelihood from the lumber
industry.

LC-USF34-17854-E

[Careyville, a small town on the
Choctawhatchee River in Holmes
County, was a farming and lumber
center with a sawmill that cut 1 million
board feet of pine and hardwood
lumber a week.]

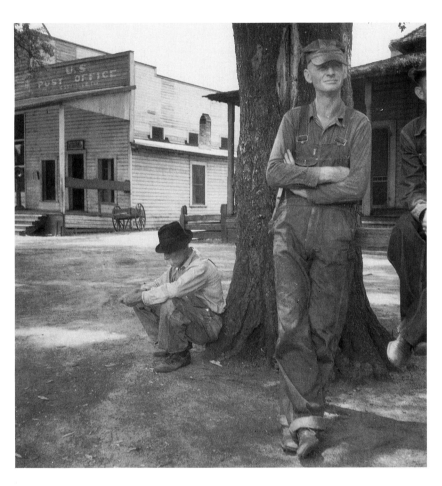

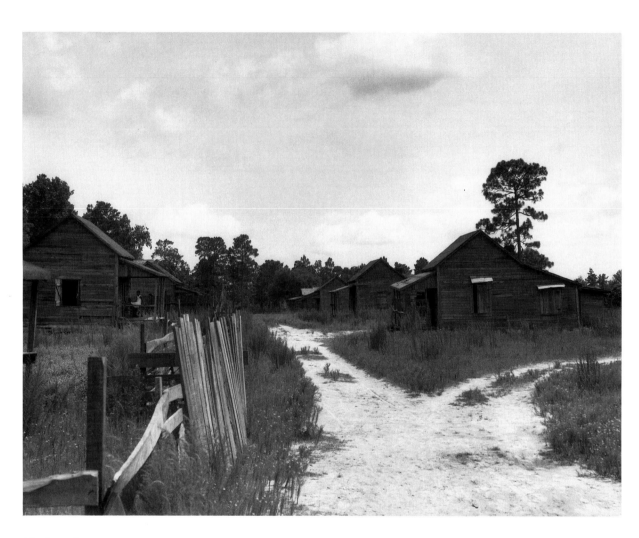

45 ▪ Dorothea Lange

Careyville. July 1937. A sawmill
village abandoned but for a few
Negro families. The rest of the
people scattered after the closing
of the mill.

LC-USF34-17685-C

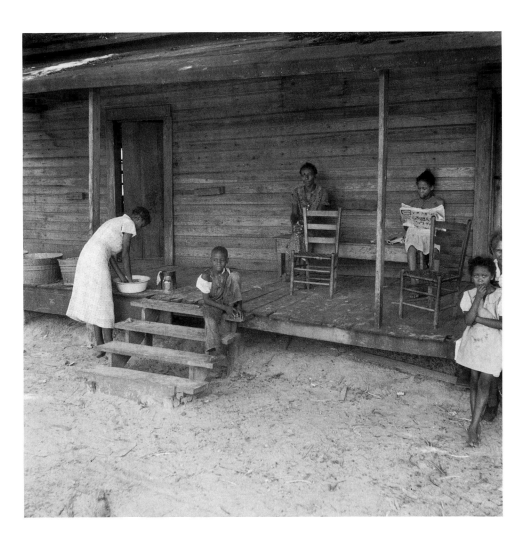

46 ▪ Dorothea Lange

Careyville. July 1937. Stranded residents who formerly earned a livelihood from the lumber industry.

LC-USF34-17852-E

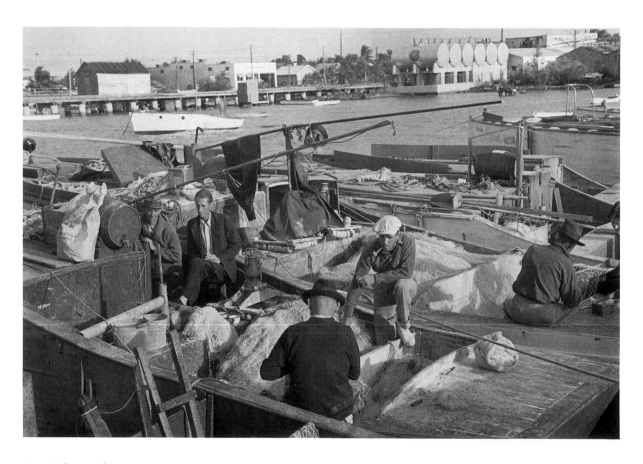

47 ▪ Arthur Rothstein

Key West. January 1938.
Fishermen.

LC-USF33-2700-M4

[The end of the Florida real estate
boom in 1926 was further
compounded in Key West by the
elimination of military bases and a
sharp decline in the cigar industry.
Between 1920 and 1930, the
population of the city fell from 18,749
to 13,445. Major relief efforts were
undertaken by the Civil Works
Administration (CWA) and the
Federal Emergency Relief
Administration (FERA), which
encouraged the expansion of the
tourist industry.]

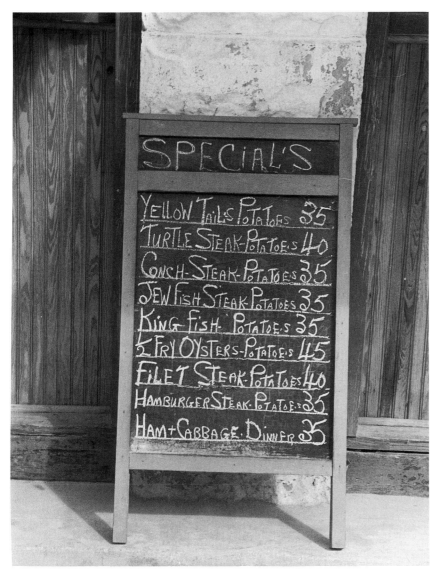

48 ▪ Arthur Rothstein

Key West. January 1938. A restaurant sign.

LC-USF33-2703-M1

Frostproof vicinity. January 1939.
A sign along the highway.

LC-USF34-50526-D

[The Townsend Plan was named for
Francis E. Townsend, a retired
physician, who advocated federal aid
for the elderly. It was introduced at a
time when only half of the states in the
country had any provisions for old-age
pensions. Although many economists
felt that specific aspects of the plan
were impractical, it struck a responsive
chord with the nation's elderly.
Pressure built for a reasonable federal
response, and in 1935 Congress passed
the Social Security Act, which
incorporated many of the features first
proposed by Townsend.]

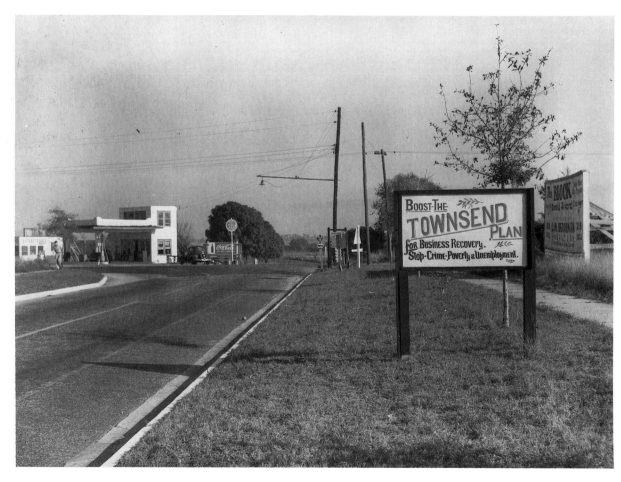

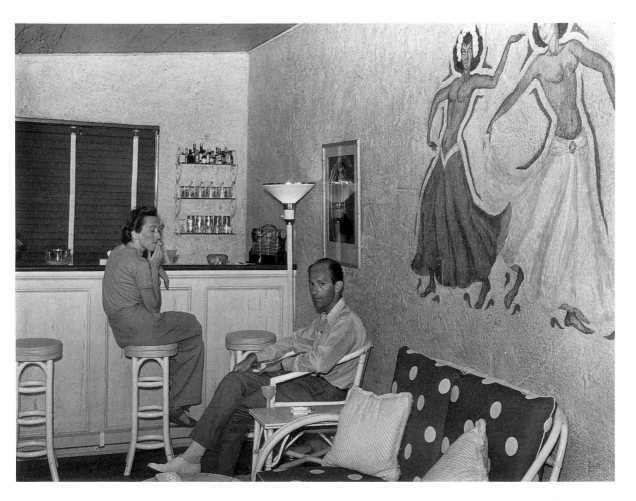

50 ▪ Marion Post Wolcott

Miami Beach. January 1939. A
bar in a private home.

LC-USF34T01-51218-D

Miami Beach. January 1939. An
employment agency office.

LC-USF34T01-50772-E

[By 1939, employment opportunities
were improving in Florida. The WPA
rolls, which had reached a peak of
55,000 persons in 1938, were cut to
37,000 persons by September 1,
1939.]

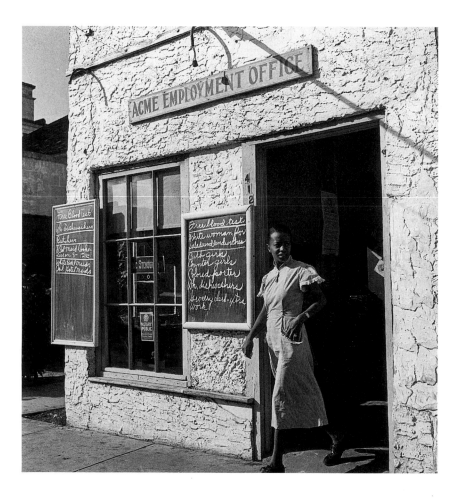

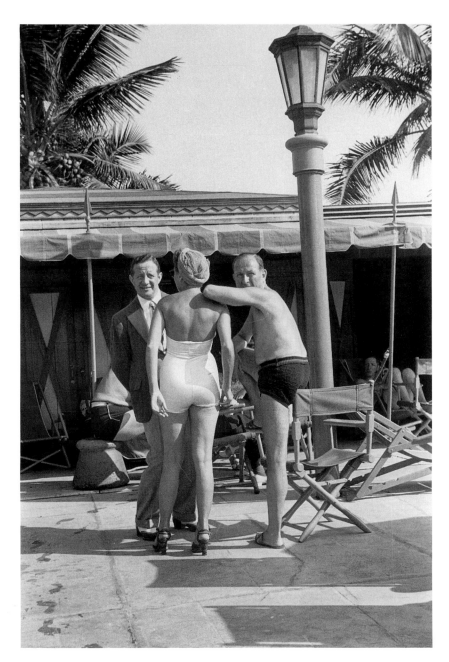

52 ▪ Marion Post Wolcott

Miami Beach. January 1939. A
beach scene.

LC-USF3301-30464-M3

[Miami Beach was incorporated in
1915. At the turn of the century it was
little more than a tangled wilderness of
red, white, and black mangroves, sea
grapes, and scrub palmetto. Before the
Collins Bridge was completed in 1913
(at the time it was the longest wooden
bridge in the world), excursion boats
carried bathers from the mainland to
the island, where crude frame shelters
served as bath houses.]

Miami. February 1939. The pari-mutuel windows at the Hialeah Park horse races.

LC-USF3301-30463-M2

[Hialeah Race Track, originally named the Miami Jockey Club, opened on January 15, 1925. Seven years later, almost to the day, the park reopened, this time with legalized pari-mutuel wagering. The park in the center oval of the track included a thirty-two-acre lake that was the home for pink flamingoes imported from Cuba.]

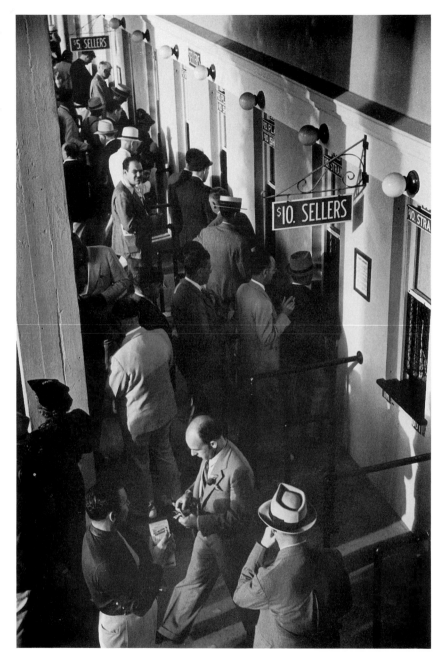

Lakeland vicinity. February 1939.
Picking strawberries.

LC-USF33-30487-M4

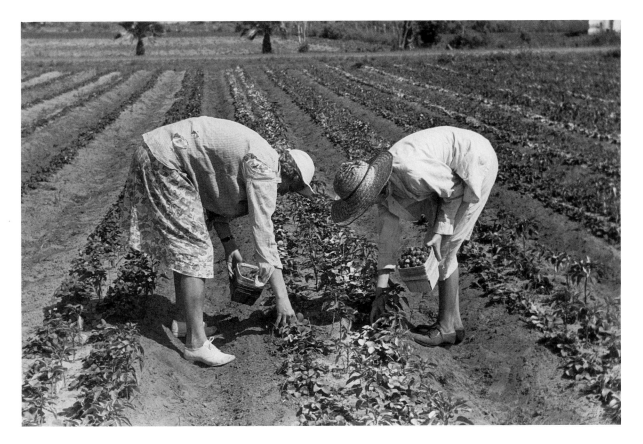

Belle Glade. January 1939. A
migrant packing house worker's
camp.

LC-USF34-51138-D

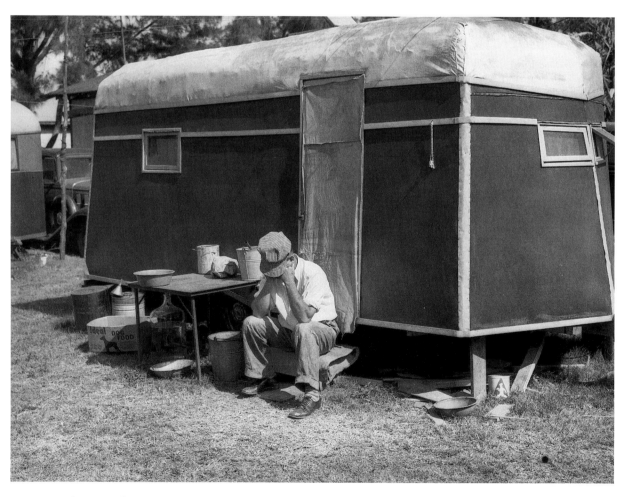

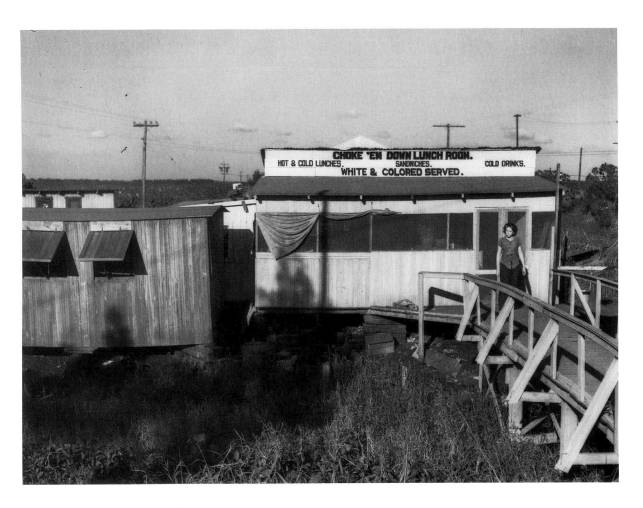

56 ▪ Marion Post Wolcott

Belle Glade vicinity. January 1939. A lunch room.

LC-USF34-50500-D

Belle Glade. January 1939. The home of a migrant packing house worker. The only bed—for six persons—is standing in the corner rolled up. These people formerly lived in Tennessee. The parents leave the children alone when they are working.

LC-USF34-50912-D

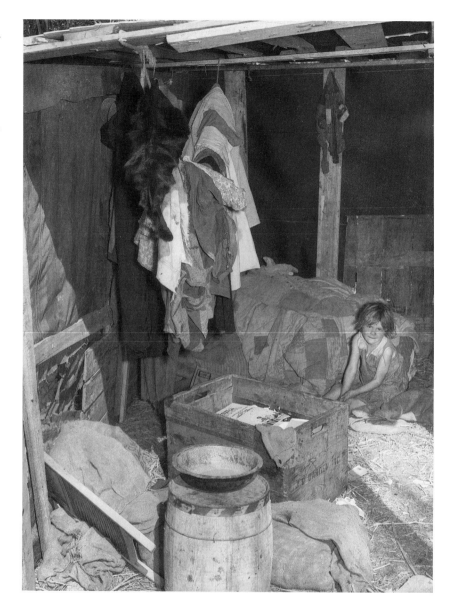

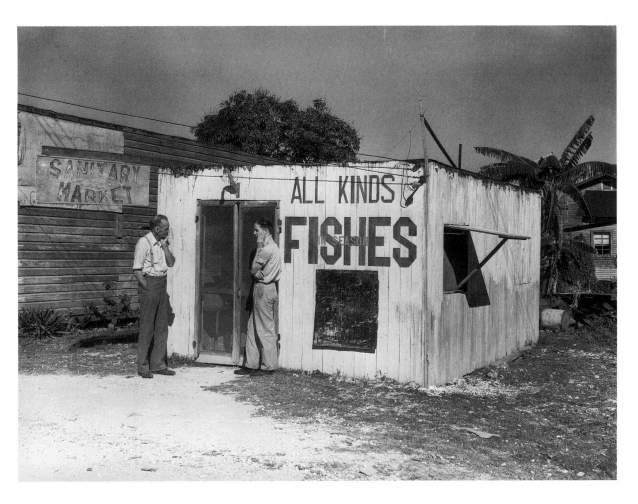

58 ▪ Marion Post Wolcott

Belle Glade. January 1939. A fish market operated by a white man.

LC-USF34-50491-D

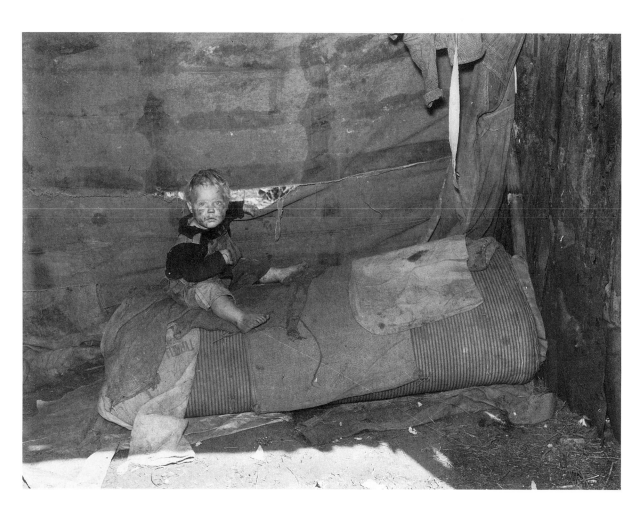

59 ▪ Marion Post Wolcott

Belle Glade. January 1939.
"Buddy," the youngest child of
packing house workers, sitting on
the only bed—for six people—in
their quarters. It is rolled out on
the floor at night and rolled up
and placed in the corner during
the day.

LC-USF34-50905-D

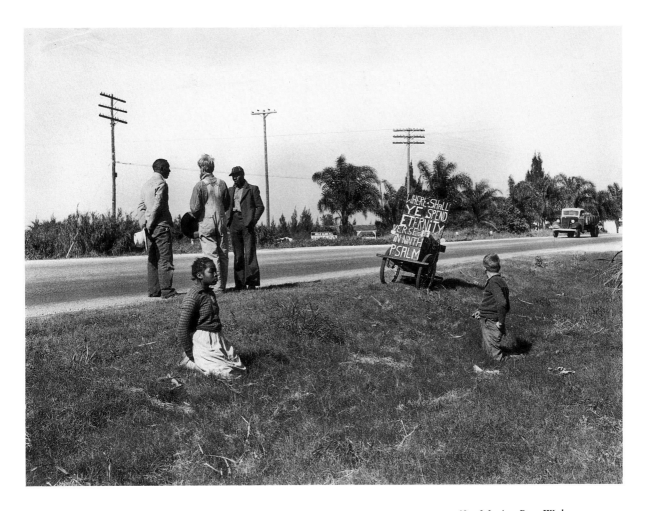

60 ▪ Marion Post Wolcott

Belle Glade. January 1939. A
traveling preacher talking to two
Negroes.

LC-USF34-50927-D

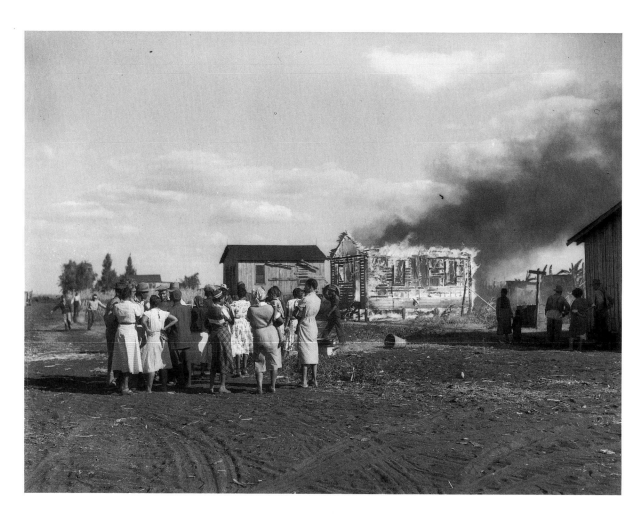

61 ▪ Marion Post Wolcott

Lake Harbor. January 1939.
Negro agricultural laborers
watching one of their houses burn
to the ground. All they have left is
shown in the foreground.

LC-USF34-50941-D

Lake Harbor. January 1939. The home of migrant agricultural workers who are just returning from the fields.

LC-USF34-50933-D

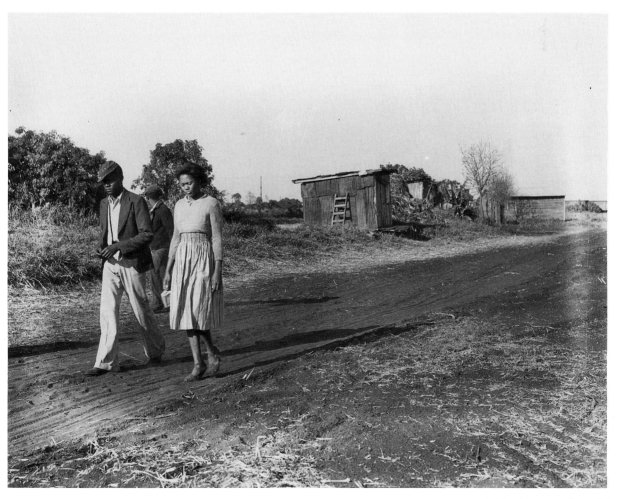

63 ▪ Marion Post Wolcott

Clewiston. January 1939. Cut sugar cane being carried to the trucks of the U.S. Sugar Corporation.

LC-USF34-51089-E

[The harvesting of sugarcane in the Everglades began in November and continued through April. Stalks averaged fifteen feet in height. The work was extremely dangerous, and the pay was low.]

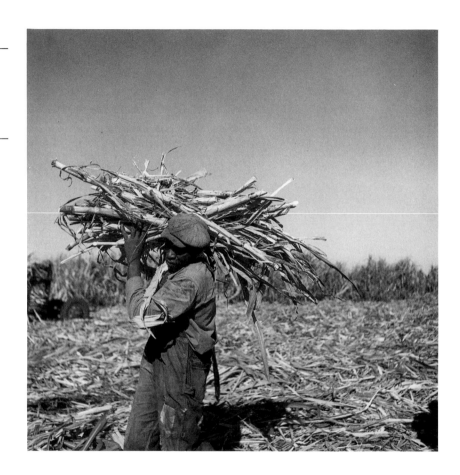

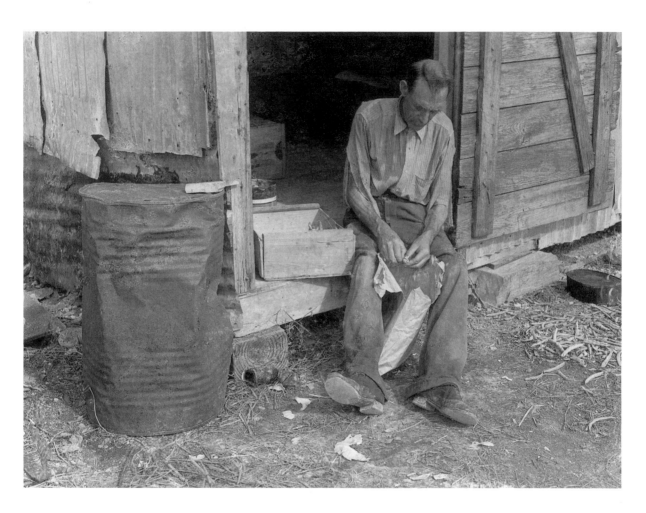

64 ▪ Marion Post Wolcott

Homestead. January 1939. A migrant agricultural worker from Tennessee, formerly a railroad man, shelling dried beans, which he got in the fields, for his supper.

LC-USF34-50873-D

65 ▪ Marion Post Wolcott

Homestead. January 1939.
Quarters for Negro migrant
agricultural workers.

LC-USF34-50866-D

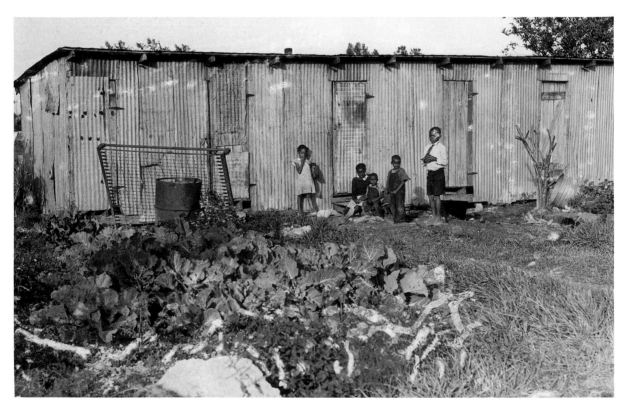

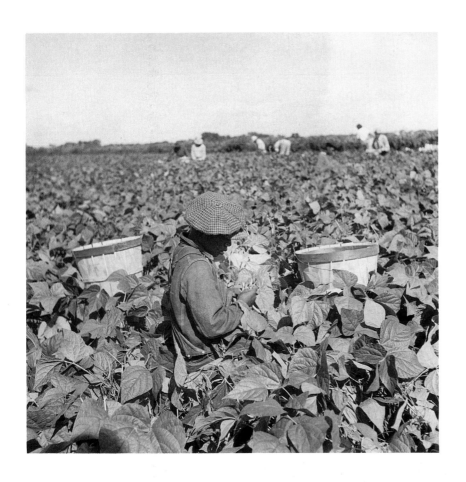

Homestead. January 1939. A nine-year-old Negro boy picking beans.

LC-USF34-50676-E

[The rapid increase in the population of Florida cities, particularly along the southern coasts of the state, provided an important outlet for crops from farming areas such as Homestead and Florida City, which are close to urban centers.]

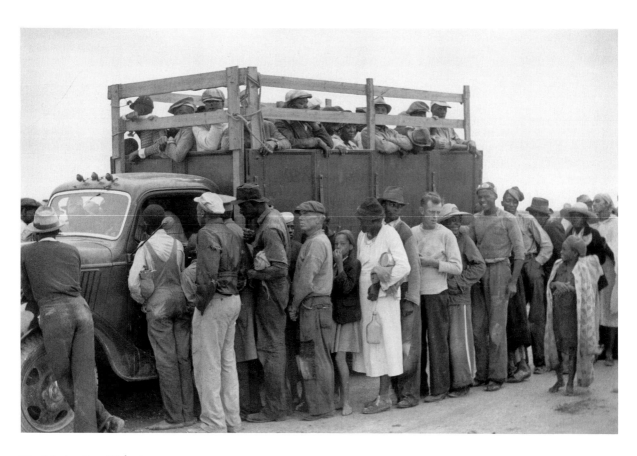

67 ▪ Marion Post Wolcott

Homestead. February 1939.
Migrant vegetable pickers waiting
after work to be paid.

LC-USF33-30491-M3

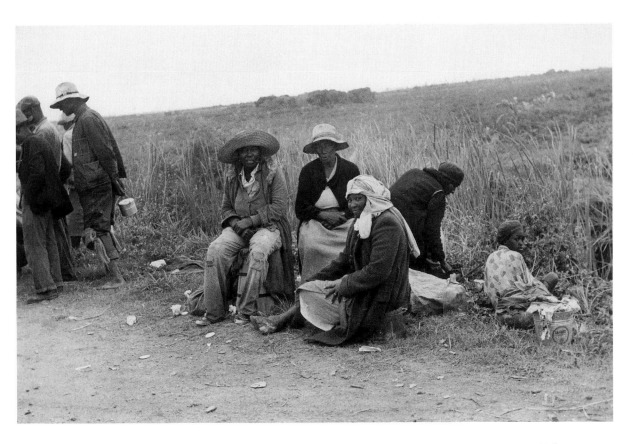

68 ▪ Marion Post Wolcott

Homestead vicinity. February 1939. Migrant vegetable pickers waiting after work to be paid.

LC-USF33-30444-M3

Canal Point. February 1939. A migrant packing house laborer and his family.

LC-USF34-51185-E

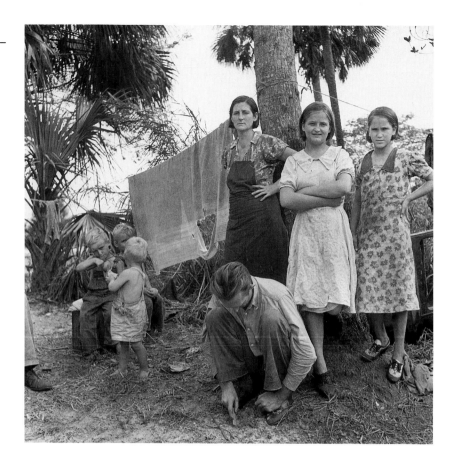

Plant City. March 1939. A strawberry festival and carnival.

LC-USF33-30474-M2

[Once a center for cotton growing, by the end of the depression Plant City supplied three-fourths of the country's midwinter strawberry crop. The growing season was from December to March, and the Strawberry Festival took place each February.]

Pahokee. April 1939. A whirling plough used by the U.S. Sugar Corporation in soft powdery muck soil to prepare the soil for planting sugar cane.

LC-USF34-51230-D

[In sugarcane production rotary plowing was necessary to aerate the soil. Cuttings are used to plant cane; they take root and are ready for harvest within a year. A single planting can produce as many as seven or eight crops, as new growth sprouts from the roots of cut stalks.]

Miami Beach. April 1939. The entrance to one of the better hotels.

LC-USF34T01-51215-D

[The Roney Plaza was among the outstanding hotels in Florida. Built by N. B. T. Roney, it officially opened for business in February 1926 but lasted only forty-two years. On August 1, 1968, the grand hotel was torn down to make way for an apartment building.]

73 ▪ Marion Post Wolcott

Belle Glade. June 1940. Some of
the younger members of the camp
in front of the post office, at the
Osceola Migratory Labor Camp,
a Farm Security Administration
project.

LC-USF34-54070-D

Belle Glade. June 1940. An
isolation unit for contagious
diseases at the Osceola Migratory
Labor Camp, a Farm Security
Administration project.

LC-USF34-54113-D

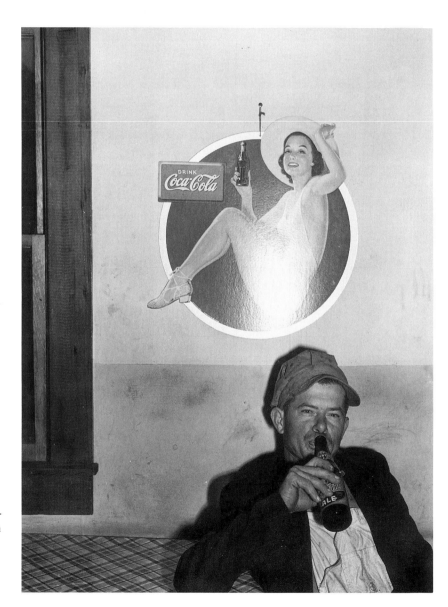

75 ▪ Marion Post Wolcott

Starke. December 1940. A Finnish construction worker from New York drinking beer at a café near Camp Blanding.

LC-USF34-56674-D

94 FSA Photographs

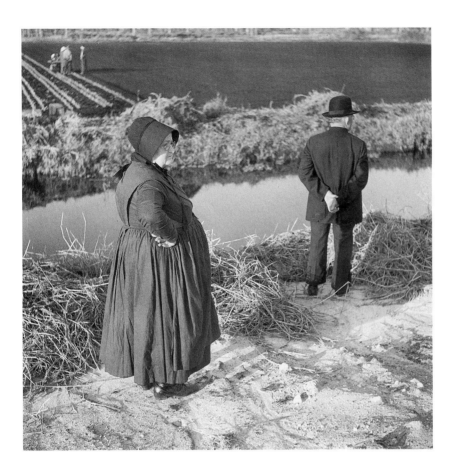

Sarasota vicinity. January 1941.
Mennonite farmers from
Pennsylvania observing the
farming methods.

LC-USF34-57268-E

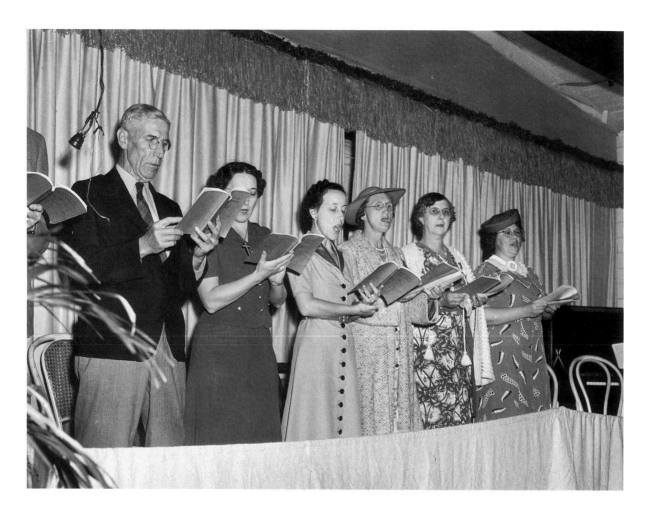

77 ▪ Marion Post Wolcott

Sarasota. January 1941. Choir singing at a Sunday church service.

LC-USF34-56990-D

Sarasota. January 1941. A man reading a magazine beside his trailer home.

LC-USF34-57057-D

[Colonies of trailer tourists would sometimes move as a group across the state, and in the 1930s annual conventions were held in Sarasota in January.]

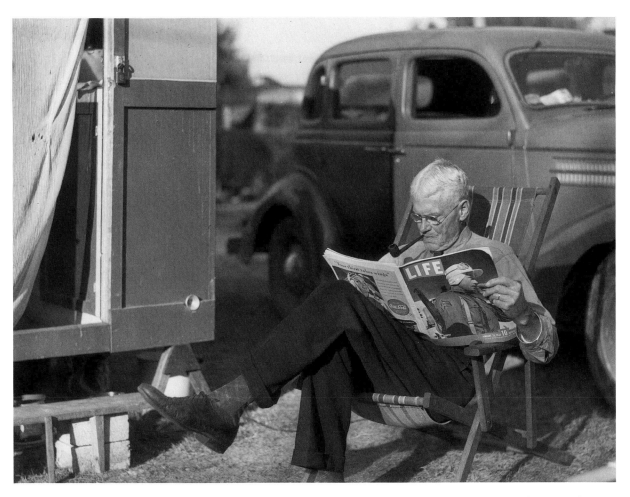

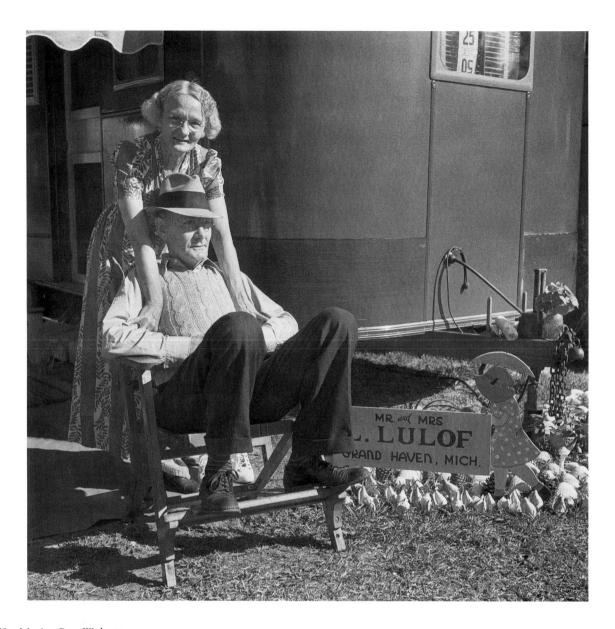

79 ▪ Marion Post Wolcott

Sarasota. January 1941. Guests of
a trailer park.

LC-USF34-56906-E

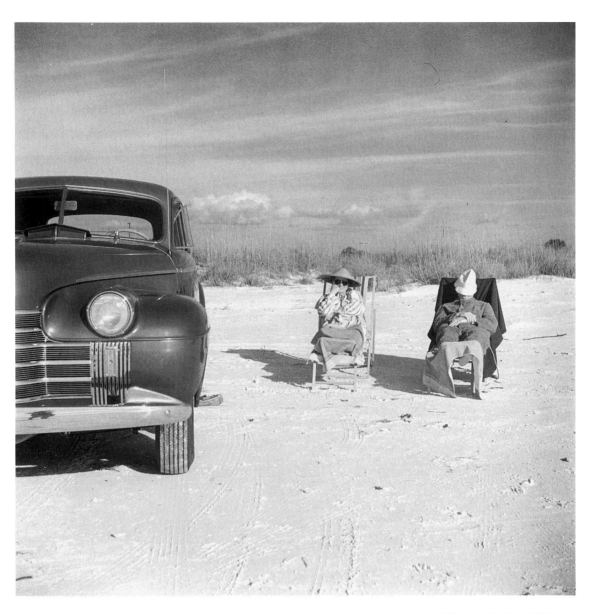

80 ▪ Marion Post Wolcott

Sarasota. January 1941. Guests of
a trailer camp enjoying the sun
and sea breeze.

LC-USF34-56924-E

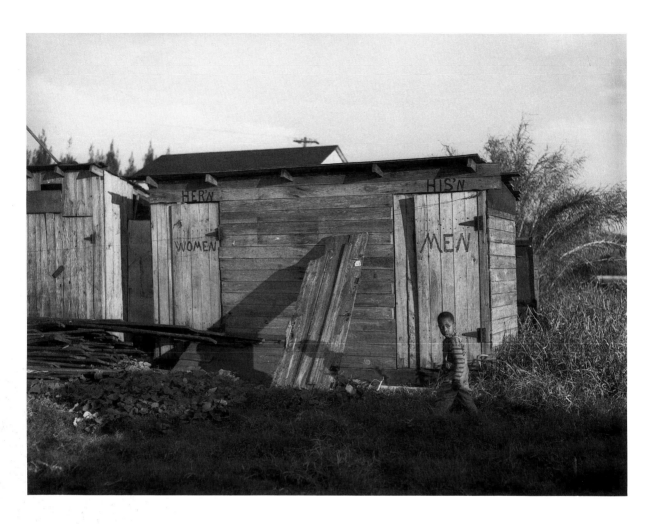

81 ▪ Marion Post Wolcott

Pahokee. February 1941. Sanitary
facilities for agricultural workers
who are living at the Pahokee
"hotel."

LC-USF34-57237-D

Pahokee. February 1941. The
Pahokee "hotel"—housing for
Negro migratory vegetable
pickers and laborers.

LC-USF34-57103-D

[Pahokee is derived from the Seminole
pah-hay-okee, which means grassy
water. The town, built below the
Okeechobee dike, became a major
shipping point for winter vegetables
during the 1930s.]

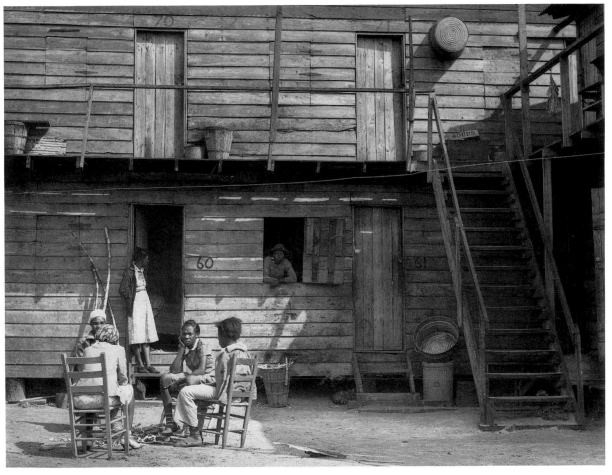

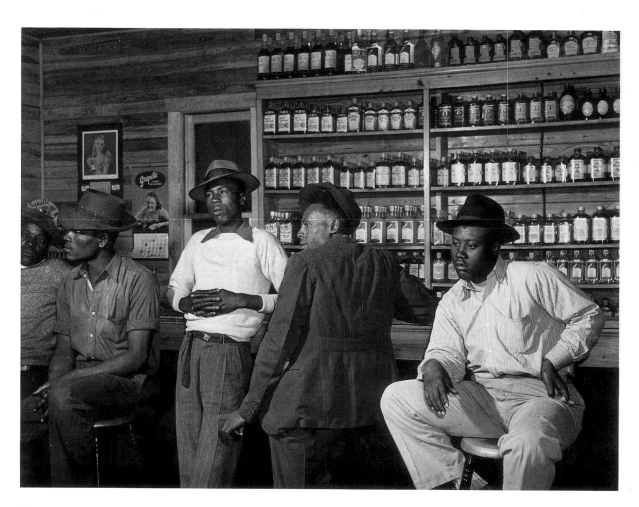

83 ▪ Marion Post Wolcott

South Central Florida. February
1941. A "juke joint" and bar in
the vegetable section of the Glades
area.

LC-USF34-57087-D

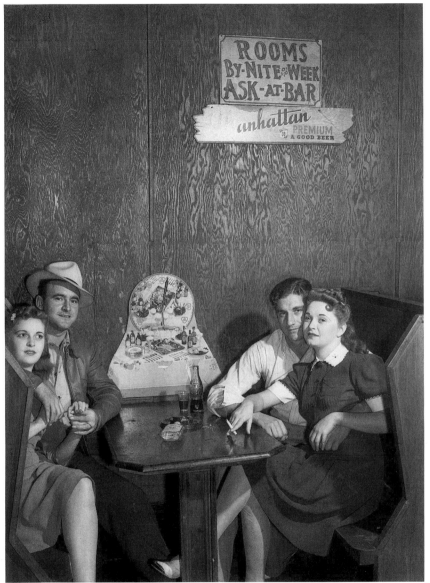

South Central Florida. [February 1941.] Young people in a "juke joint" and bar in the vegetable section of the Glades area.

LC-USF34-57094-D

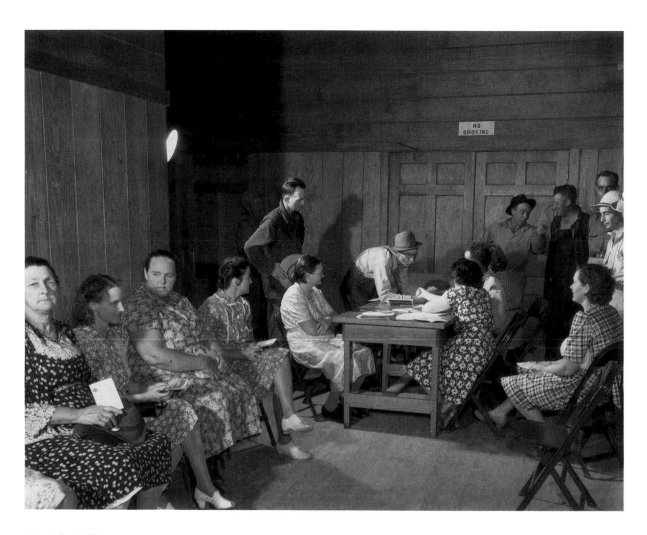

85 ▪ John Collier

Escambia farms. June 1942. A
Florida "cracker" tries to "argue
it out" with the sugar ration
board.

LC-USF34-82745-C

[The term *cracker* now refers to a
Florida or Georgia backwoods
individual of dubious character and
aptitude. Originally, however, it
merely indicated that the person was
rural and native born. In Florida,
cracker is said to have been derived
from the cracking of a bullwhip.]

Escambia farms. June 1942.
Boiling wash water on the
McLelland farm.

LC-USF34-82604-E

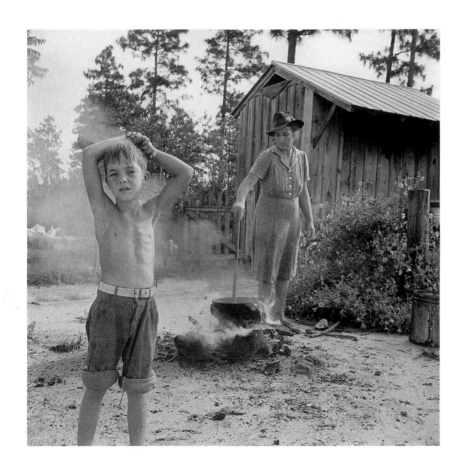

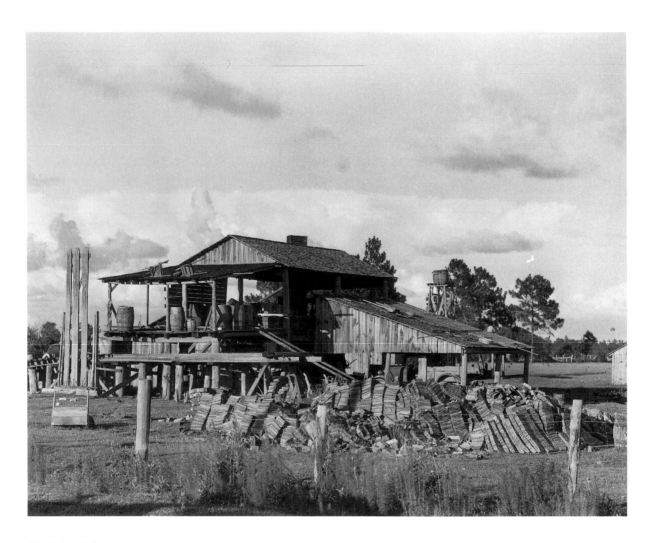

87 ▪ John Collier

Baker. June 1942. The turpentine
forests are about gone, but this
mill on the edge of Baker still
distills the gum.

LC-USF34-82693-C

[In the production of turpentine, sap
collected from slash pines was placed
into a copper kettle built into a brick
firebox with a removable lid. When
the temperature of the sap was raised
to 212°F, fumes were conducted
through a tube attached to the lid and
then through a long copper "worm"
submerged in cold water.
Condensation occurred and the
turpentine could be collected.]

Baker. June 1942. Cross-roads in nearest town to Escambia farms.

LC-USF34-82686-C

89 ▪ John Collier

Falco. June 1942. Grist mill which
has been grinding corn for eighty
years.

LC-USF34-82758-C

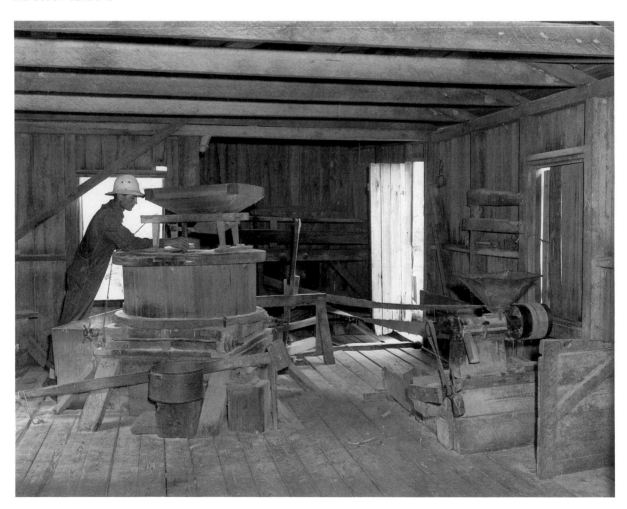

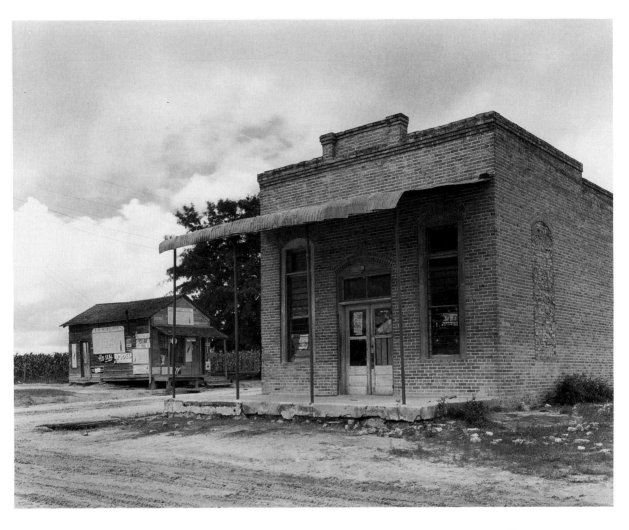

90 ▪ John Collier

Falco. June 1942. Falco was a
thriving, overcrowded town in the
20s. Now most of its buildings
have been fired or torn down, so
that today it is only a post office
and a crossroads.

LC-USF34-82741-C

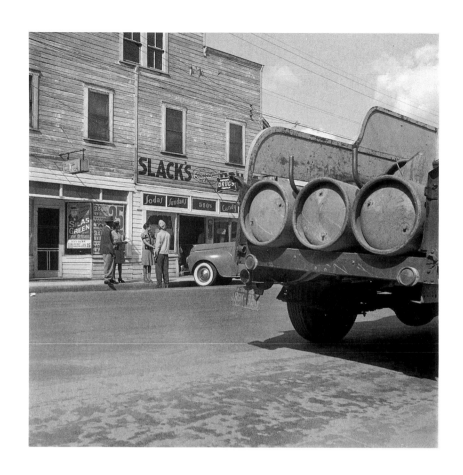

91 ▪ Gordon Parks

Daytona Beach. January 1943.
Street scene.

LC-USW3-16840-E

110 FSA Photographs

Daytona Beach. February 1943.
Young boy on his way to church
on Sunday morning.

LC-USW3-17020-E

[The black settlement in Daytona was
along the western edge of the city. It
was made up of one- and two-room
wood-frame houses and a small
business district. African-Americans
made up about one-third of the city's
population in the late 1930s and
1940s. During the tourist season,
many blacks were employed in local
hotels as waiters, bellhops, and cooks.]

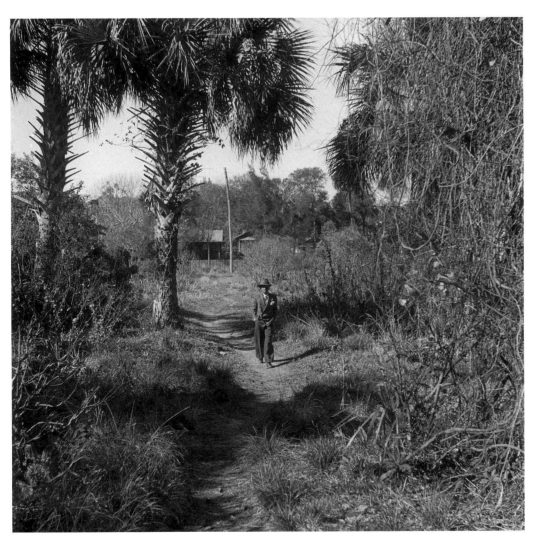

Daytona Beach. January 1943.
Bethune-Cookman College.
Entrance to Faith Hall.

LC-USW3-14852-E

[Bethune-Cookman College was
founded in 1904 by Mary McLeod
Bethune as the Daytona Normal and
Industrial Institute for Girls. It became
coeducational in 1922, when it merged
with the Cookman Institute. Bethune-
Cookman, the first private school in
Florida that provided college-level
instruction to African-American
students, had a student population of
about 700 and 130 faculty members
by the end of the depression.]

94 ▪ Gordon Parks

Daytona Beach. February 1943.
Students in home economics class.

LC-USW3-16932-C

Notes

1. Theodore G. Joslin, *Hoover Off the Record*, pp. 364–66.

2. Henry A. Wallace, *America Must Choose*, p. 8.

3. Paul V. Maris, "Farm Tenancy," in U.S. Department of Agriculture, *Yearbook of Agriculture, 1940*, p. 889; Joseph Gaer, *Toward Farm Security: The Problems of Rural Poverty and the Work of the Farm Security Administration*, p. 7.

4. Lawrence Elmer Will, *Okeechobee Hurricane and the Hoover Dike*, pp. 85–88.

5. Florida Department of Agriculture, *Agricultural Statistics of Florida. Twenty-first Census, 1936–37*, pp. 9, 394.

6. Colin D. Gunn and John Wallace, *Report on Land Problems and Conditions in Florida*, p. 30.

7. National Oceanic and Atmospheric Administration, *Climates of the States*, vol. 1, *Eastern States*, pp. 47, 65.

8. "Florida's Optimism Once More Revives," *New York Times*, July 28, 1928, sec. 3, p. 1.

9. "Editorial Comment: Florida Sales Increase."

10. Donald H. Grubbs, "The Story of Florida's Migrant Farm Workers," pp. 105–7.

11. Gunn and Wallace, *Report on Land Problems*, pp. 13–14.

12. Carey McWilliams, *Ill Fares the Land: Migrants and Migratory Labor in the United States*, p. 170.

13. Federal Writers' Project, *The WPA Guide to Florida*, p. 474, hereafter cited as the *WPA Guide*.

14. Zora Neale Hurston, *Their Eyes Were Watching God*, p. 196.

15. McWilliams, *Ill Fares the Land*, p. 21.

16. "What a Dole Would Cost America."

17. Eleanor G. Kimble, "Footloose Families," p. 163.

18. Violet Wood, "Cranberries, Tomatoes, Potatoes and Onions," pp. 17, 58.

19. U.S., Congress, House, Select Committee to Investigate the Interstate Migration of Destitute Citizens, *Hearings*, part 2, p. 599.

20. McWilliams, *Ill Fares the Land*, p. 171.

21. Howard C. Hill and Rexford G. Tugwell, *Our Economic Society and Its Problems*, p. 66.

22. Franklin D. Roosevelt, *The Public Papers and Addresses of Franklin D. Roosevelt*, 1:815.

23. Gaer, *Toward Farm Security*, pp. 21–22.

24. "Roosevelt Farm Tenancy Message."

25. Lief A. Dahl, "Class War in the Corn Belt," p. 13; "Farmers Block Mortgage Sale."

26. John Herling, "Field Notes from Arkansas" *WPA Guide*, pp. 94–98.

27. Raymond Moley, *The First New Deal*, p. 227.

28. Agricultural Adjustment Administration, *Agricultural Adjustment: A Report of Administration of the Agricultural Adjustment Act*, pp. 260–62.

29. Quote from "Editorial Comment: Florida Sales Increase"; Tom Terrill and Jerrold Hirsch, eds., *Such as Us: Southern Voices of the Thirties*, p. 43.

30. Dorothea Lange and Paul Schuster Taylor, *An American Exodus: A Record of Human Erosion*, p. 80.

31. Rexford Guy Tugwell, *The Democratic Roosevelt*, p. 423; Resettlement Administration, *Land Policy Circular: Formation of the Resettlement Administration*, p. 1.

32. Richard S. Kirkendall, "The New Deal and Agriculture," p. 86; Hill and Tugwell, *Our Economic Society and Its Problems*, p. 66.

33. [John Franklin Carter], *The New Dealers*, p. 85; "The Shape of Things," *The Nation*, November 28, 1936, p. 618.

34. Jerrell H. Shofner, "Roosevelt's 'Tree Army': The Civilian Conservation Corps in Florida," p. 455.

35. Florida Emergency Relief Administration, *Unemployment Relief in Florida, July 1932–March 1934*; Florida Welfare Board, *First Annual Report of the State Welfare Board*, p. 24.

36. W. A. Hartman, "Re-Vamping Land Use in Florida," p. 6; L. C. Gray, "Florida Lands Gaining Wealth Under RA Care."

37. State Planning Board, *Forest Resources, Parks and Recreation*, p. 60. See also Sarah Davis, "Federalists to Convert Wakulla, Leon Submarginal Land into Richer Fields."

38. Gray, "Florida Lands Gaining Wealth Under RA Care."

39. Rexford Guy Tugwell, "Down to Earth," p. 38.

40. Rexford G. Tugwell and Grace F. Tugwell, interview by Richard K. Doud, hereafter cited as Doud/Tugwell interview.

41. Werner J. Severin, "Cameras with a Purpose: The Photojournalists of the FSA," p. 192; Nancy Wood, "Portrait of Stryker," in *In This Proud Land*, ed. Nancy Wood and Roy Emerson Stryker, p. 11.

42. John Durniak, "Focus on Stryker," pp. 62, 80.

43. Wood and Stryker, eds., *In This Proud Land*, pp. 10–11.

44. Roy E. Stryker, "A Great Photo-Documentarian"; Roy Stryker, "The Lean Thirties," p. 9.

45. Roy Emerson Stryker to Helen Hill Miller, October 11, 1960; see also Stryker to Robert Doherty, August 9, 1962, both in Roy E. Stryker Papers, hereafter cited as RES Papers.

46. Beaumont Newhall, "The Questing Photographer: Dorothea Lange," in *Dorothea Lange Looks at the American Country Woman*, ed. Dorothea Lange, p. 6.

47. "Interview with Roy Stryker," in *The Camera Viewed: Writings on Twentieth Century Photography*, ed. Peninah R. Petruck, p. 143.

48. Carl Mydans, *Carl Mydans, Photojournalist*.

49. Jack Hurley, *Portrait of a Decade: Roy Stryker and the Development of Documentary Photography in the Thirties*, pp. 42, 44; Mydans, *Carl Mydans*, p. 8.

50. John Collier to Stryker, transcribed tape recorded message, March 1959, p. 2, RES Papers.

51. Hank O'Neil, ed., *A Vision Shared*, p. 60; Leslie Katz, "Interview with Walker Evans," pp. 85, 87.

52. Stryker to Edna Barrett, August 29, 1962, RES Papers; Archibald Macleish, "Foreword," in *The Photographic Eye of Ben Shahn*, ed. Davis Pratt, pp. vii–ix.

53. Milton Meltzer, *Dorothea Lange: A Photographer's Life*, p. 104.

54. Roy Emerson Stryker, "The FSA Collection of Pictures," in *In This Proud Land*, ed. Wood and Stryker, p. 7.

55. Arthur Rothstein, interview by Richard K. Doud; U.S. Farm Security Administration, *Report of the Administrator of the Farm Security Administration, 1941*, p. 3.

56. "A New High in Publicity," *Cincinnati Times*, December 29, 1936.

57. Collier to Stryker, March 1959, pp. 13–14, RES Papers; Bernarda Shahn in *A Vision Shared*, ed. O'Neil, p. 7; Stryker to Lange, January 3, 1936, RES Papers; Walker Evans to John Carter, August 17, 1935, RES Papers.

58. Paul Vanderbilt, "Preliminary Report on the Organization of a Master Photograph File for the Publications Section of the Office of War Information," October 31, 1942, p. 6, RES Papers; Bernarda Shahn, p. 6.

59. Wood and Stryker, eds., *In This Proud Land*, p. 14.

60. Marion Post Wolcott to Stryker, July 28, 29, 1940, RES Papers.

61. Wood and Stryker, eds., *In This Proud Land*, p. 14; Mark Adams, n.d., RES Papers; Robert Doherty, "The Elusive Stryker," in *Roy Stryker: The Humane Propagandist*, ed. James C. Anderson, p. 8.

62. James L. McCamy, *Government Publicity: Its Practice in Federal Administration*, p. 81; Stryker to Robert E. Girvin, June 10, 1947, RES Papers. See also Robert E. Girvin, "Photography as Social Documentation," pp. 218–19.

63. Tugwell-Doud interview.

64. Collier to Anthony Caruso, n.d. (ca. 1954), RES Papers.

65. Roy E. Stryker, "Photography in Social Science Research," speech delivered to the Institute of Women's Professional Relations Conference on Photography, New York, February 9, 1940, transcribed, RES Papers.

66. O'Neil, *A Vision Shared*, p. 116; Hurley, *Portrait of a Decade*, p. 58; Durniak, "Focus on Stryker," p. 64.

67. Stryker to Lange, March 24, 1937, RES Papers.

68. Stryker to Russell Lee, April 17, 1937, RES Papers.

69. Stryker, "Photography in Social Science Research," p. 76.

70. Stryker to Robert Doherty, August 9, 1962, RES Papers; Carlisle Bargeron, "Invisibly Supported," p. 28.

71. Stryker to Lange, January 4, 1936, to Rothstein, May 23, 1936, RES Papers.

72. Arthur Rothstein, *Photojournalism*, pp. 27, 30.

73. Elizabeth McCausland, "Documentary Photography."

74. Sidney Baldwin, *Poverty and Politics: The Rise and Decline of the Farm Security Administration*, p. 120; Paul Mallon, "News Behind the News"; Tugwell, *The Democratic Roosevelt*, pp. 472–73.

75. C. B. Baldwin, interview with Richard K. Doud, hereafter cited as Doud/Baldwin interview.

76. O'Neil, *A Vision Shared*, p. 61.

77. Stryker to Grace Falke, August 13, 1937, RES Papers.

78. Hurley, *Portrait of a Decade*, p. 50.

79. Paul Strand to Stryker, June 20, 1938, RES Papers; Robert E. Snyder, "Marion Post and the Farm Security Administration in Florida," p. 467.

80. Theodore Pratt, "Land of the Jook," p. 20.

81. "Reporter with a Camera."

82. John Vachon, "Commentary: Tribute to a Man, an Era, an Art," pp. 96–97.

83. Stryker to Jack Delano, May 6, 1941, to Lee and Delano, December 13, 1940, RES Papers.

84. Stryker to Delano, September 12, 1940, RES Papers.

85. *U.S. Camera Annual, 1939*, pp. 43–47; Roy Stryker, Address to Conference on Photography, Institute of Design, Chicago, August 13, 1946, RES Papers.

86. Archibald MacLeish, *Land of the Free*, p. 89; Stryker to Falke, August 13, 1937, RES Papers.

87. Severin, "Cameras with a Purpose," p. 194.

88. Stryker to Lee, May 21, 1941, RES Papers.

89. Hartley E. Howe, "You Have Seen Their Pictures," p. 238.

90. Dorothea Lange, *The Making of a Documentary Photographer*, p. 181.

91. Stryker to Delano, December 22, 1941, RES Papers.

92. Oren Stephens, "FSA Fights for Its Life," p. 486.

93. Rexford G. Tugwell, *The Art of Politics*, pp. 201–2.

94. Stryker to Lange, n.d. (ca. 1940), RES Papers; Hurley, *Portrait of a Decade*, p. 164.

95. Stryker to Lange, September 16, 1943, RES Papers.

96. Stryker to Jonathan Daniels, September 13, 1943, RES Papers; Amy Conger, "The Amarillo FSA Symposium: A Report," p. 52.

97. Stryker to Daniels, September 13, 1943, RES Papers; Roy Stryker, "Notice of Resignation," October 2, 1943, RES Papers.

98. Alan Trachtenberg, "Reading the File," in *Documenting America, 1935–1943*, ed. Carl Fleischhauer and Beverly Brannan, p. 45.

99. Vachon, "Commentary: Tribute to a Man," p. 99.

Bibliography

Collections

Farm Security Administration Collection. Prints and Photographs Division, Library of Congress, Washington, D.C.

Stryker, Roy E. Papers. University of Louisville Photographic Archives, Ekstrom Library, Louisville, Kentucky.

Government Publications

Agricultural Adjustment Administration. *Agricultural Adjustment: A Report of the Administration of the Agricultural Adjustment Act.* Washington, D.C.: Government Printing Office, 1934.

Federal Writers' Project, *The WPA Guide to Florida.* Tallahassee: State of Florida Department of Public Instruction, 1939. Reprint. New York: Pantheon Press, 1984.

Florida Department of Agriculture. *Agricultural Statistics of Florida. Twenty-first Census, 1936–37.* Tallahassee: Department of Agriculture, 1938.

Florida Emergency Relief Administration. *Unemployment Relief in Florida, July 1932–March 1934.* Jacksonville: Florida Relief Administration, 1935.

Florida Welfare Board. *First Annual Report of the State Welfare Board.* Tallahassee: State Welfare Board, 1938.

Gaer, Joseph. *Toward Farm Security: The Problems of Rural Poverty and the Work of the Farm Security Administration. Washington, D.C.: Government Printing Office, 1941.*

Gunn, Colin D., and John Wallace. *Report on Land Problems and Conditions in Florida.* Washington, D.C.: National Resources Board, 1935.

National Oceanic and Atmospheric Administration. *Climates of the States.* Vol. 1, *Eastern States.* Port Washington, N.Y.: Water Information Center, 1974.

Resettlement Administration. *Land Policy Circular: Formation of the Resettlement Administration.* Washington, D.C.: Resettlement Administration, 1935.

State Planning Board. *Forest Resources, Parks and Recreation.* Tallahassee: Florida State Planning Board, 1939.

U.S. Congress. House. Select Committee to Investigate the Interstate Migration of Destitute Citizens. *Hearings.* 76th Cong., 3d sess., 1940.

U.S. Department of Agriculture. *Yearbook of Agriculture, 1940: Farmers in a Changing World.* Washington, D.C.: Government Printing Office, 1940.

U.S. Farm Security Administration. *Farm Security: The Work of the Farm Security Administration.* Rev. ed. Washington, D.C.: Government Printing Office, 1941.

———. *Migrant Farm Labor: The Problem and Some Efforts to Meet It.* Washington, D.C.: Government Printing Office, 1940.

————. *Report of the Administration of the Farm Security Administration*. Washington, D.C.: Government Printing Office, 1940.

————. *Security for Farm Tenants*. Washington, D.C.: Government Printing Office, 1940.

————. *The Farm Security Administration, 1941*. Washington, D.C.: Government Printing Office, 1941.

White, Max R., Douglas Ensminger, and Cecil Gregory. *Rich Land—Poor People*. Region 3 publication. Washington, D.C.: Farm Security Administration, 1938.

Books

Agee, James, and Walker Evans. *Let Us Now Praise Famous Men*. Boston: Houghton Mifflin, 1941.

Anderson, James C., ed. *Roy Stryker: The Humane Propagandist*. Louisville, Ky.: University of Louisville Photographic Archives, 1977.

Baldwin, Sidney. *Poverty and Politics: The Rise and Decline of the Farm Security Administration*. Chapel Hill: University of North Carolina Press, 1968.

Black, Patti Carr, ed. *Documentary Portrait of Mississippi: The Thirties*. Jackson: University of Mississippi Press, 1982.

Braeman, John, Robert H. Bremmer, and David Brody, eds. *The New Deal: The National Level*. Columbus: Ohio State University Press, 1975.

[Carter, John Franklin.] *The New Dealers*. New York: Literary Guild, 1934.

Childs, Harwood, ed. *Pressure Groups and Propaganda*. Philadelphia: The Annals of the American Academy of Political and Social Science, 1935.

Documentary Photography. New York: Time-Life Books, 1972. Doherty, Robert J. *Social Documentary Photography in the USA*. Garden City, N.Y.: Amphoto, 1976.

Evans, Walker. *American Photographs*. New York: Museum of Modern Art, 1938.

————. *Walker Evans*. New York: Museum of Modern Art, 1971.

————. *Walker Evans: Photographs for the Farm Security Administration, 1935–1938*. New York: Da Capo Press, 1973.

Featherstone, David, ed. *Observations: Essays on Documentary Photography*. Carmel, Calif.: Friends of Photography, 1984.

Federal Writers Project of the WPA. *These Are Our Lives*. Chapel Hill: University of North Carolina Press, 1939. Reprint. New York: W. W. Norton, 1975.

Fleischhauer, Carl, and Beverly Brannan, eds. *Documenting America, 1935–1943*. Berkeley: University of California Press, 1988.

Hardy, Forsyth, ed. *Grierson on Documentary*. London: Collins Clear-Type Press, 1946.

Hill, Howard, and Rexford Tugwell. *Our Economic Society and Its Problems*. New York: Harcourt, Brace and Co., 1934.

Hurley, Jack F. *Marion Post Wolcott: A Photographic Journey*. Albuquerque: University of New Mexico Press, 1989.

————. *Portrait of a Decade: Roy Stryker and the Development of Documentary Photography in the Thirties*. Baton Rouge: Louisiana State University Press, 1972.

————. *Russell Lee Photographer*. Dobbs Ferry, N.Y.: Morgan and Morgan, 1978.

Hurston, Zora Neale. *Their Eyes Were Watching God*. Philadelphia: J. B. Lippincott, 1937. Reprint. University of Illinois Press, 1978.

Joslin, Theodore G. *Hoover Off the Record*. Garden City, N.Y.: Doubleday, Doran, 1934.

Kester, Howard. *Revolt Among the Sharecroppers*. New York: Covici Friede Publishers, 1936.

Kirkendall, Richard S. "The New Deal and Agriculture." In *The New Deal: The National Level*, edited by John Braeman, Robert Bremmer, and David Brody. Columbus: Ohio State University Press, 1975.

Lange, Dorothea, ed. *Dorothea Lange Looks at the American Country Woman*. Fort Worth, Tex.: Amon Carter Museum, 1967.

Lange, Dorothea, and Paul Schuster Taylor. *An American Exodus: A Record of Human Erosion*. New York: Reynal and Hitchcock, 1939.

Lyons, Nathan, ed. *Photographers on Photography*. Englewood Cliffs, N.J.: Prentice-Hall, 1966.

McCamy, James L. *Government Publicity: Its Practice in Federal Administration*. Chicago: University of Chicago Press, 1939.

MacLeish, Archibald. *Land of the Free*. New York: Da Capo Press, 1938. Reprint. 1977.

McWilliams, Carey. *Ill Fares the Land: Migrants and Migratory Labor in the United States*. London: Faber and Faber, 1945.

Meltzer, Milton. *Dorothea Lange: A Photographer's Life*. New York: Farrar, Straus, Giroux, 1978.

Meltzer, Milton, and Bernard Cole. *The Eye of Conscience: Photographers and Social Change*. Chicago: Follett, 1974.

Moley, Ray. *The First New Deal*. New York: Harcourt, Brace and World, 1966.

Mydans, Carl. *Carl Mydans, Photojournalist*. New York: Harry N. Abrams, 1985.

Nixon, Herman C. *Forty Acres and Steel Mules*. Chapel Hill: University of North Carolina Press, 1938.

Ohrn, Karin Becker. *Dorothea Lange and the Documentary Tradition*. Baton Rouge: Louisiana State University Press, 1980.

O'Neil, Hank, ed. *A Vison Shared*. New York: St. Martin's Press, 1976.

Petruck, Peninah, R., ed. *The Camera Viewed: Writings on Twentieth-Century Photography*. Vol. 1, *Photography Before World War II*. New York: E.P. Dutton, 1979.

Pratt, Davis, ed. *The Photographic Eye of Ben Shahn*. Cambridge, Mass.: Harvard University Press, 1975.

Reid, Robert L. *Picturing Minnesota: Photographs from the Farm Security Administration*. St. Paul: Minnesota Historical Society Press, 1989.

Roosevelt, Franklin D. *The Public Papers and Addresses of Franklin D. Roosevelt*. Vol. 1. New York: Random House, 1938.

Rothstein, Arthur. *Photojournalism*. Garden City, N.Y.: Amphoto, 1974.

———. *The Depression Years*. New York: Dover Publications, 1978.

Sternsher, Bernard. *Rexford Tugwell and the New Deal*. New Brunswick, N.J.: Rutgers University Press, 1964.

Stott, William. *Documentary Expression and Thirties America*. New York: Oxford University Press, 1973.

Tebeau, Charleton W. *A History of Florida*. Coral Gables, Fla.: University of Miami Press, 1975.

Terrill, Tom, and Jerrold Hirsch, eds. *Such as Us: Southern Voices of the Thirties*. New York: W. W. Norton, 1979.

The Years of Bitterness and Pride. Preface by Hiag Akmakjian. New York: McGraw-Hill, 1975.

Trachtenberg, Alan. *Reading American Photographs. Images as History: Mathew Brady to Walker Evans*. New York: Hill and Wang, 1989.

Tugwell, Rexford G. *The Art of Politics*. Garden City, N.Y.: Doubleday and Co., 1958.

———. *The Democratic Roosevelt*. Garden City, N.Y.: Doubleday, 1957.

Tugwell, Rexford, Thomas Munro, and Roy Stryker. *American Economic Life and the Means to Its Improvement*. 3d. ed. New York: Harcourt, Brace and Co., 1925.

U.S. Camera Annual, 1939. New York: Duell, Sloan and Pearce, 1939.

Wallace, Henry A. *America Must Choose*. New York: Foreign Policy Association, 1934.

Weiss, Margaret, ed. *Ben Shahn, Photographer*. New York: Da Capo Press, 1973.

Will, Lawrence Elmer. *Okechobee Hurricane and the Hoover Dike*. St. Petersburg: Great Outdoors Publishing Company, 1961.

Wood, Nancy, and Roy Emerson Stryker, eds. *In This Proud Land*. Greenwich, Conn.: New York Graphic Society, 1973.

Periodicals

"A New High in Publicity." *Cincinnati Times*, December 29, 1936.

Asbury, Dana. "Amarillo Symposium Reunites FSA Photographers." *Afterimage* 6, no. 8 (March 1979): 4.

"Bankers v. Panic." *Time*, November 4, 1929, 45–46.

Bargeron, Carlisle. "Invisibly Supported." *Nation's Business* 25, no. 10 (October 1937): 27–28, 119, 121.

Becker, Howard S. "Do Photographs Tell the Truth?" *Afterimage* 5 (February 1978): 9–13.

Bruere, Martha. "Lifting the Drought." *Survey Graphics* 23, no. 11 (November 1934): 544–47.

Conger, Amy. "The Amarillo FSA Symposium: A Report." *Exposure* (October 1979): 51–54.

Dahl, Lief A. "Class War in the Corn Belt." *The New Republic*, May 17, 1933, 12–13.

Davis, Sarah. "Federalists to Convert Wakulla, Leon Submarginal Land into Richer Fields." *Tallahassee Democrat*, March 22, 1936.

Durniak, John. "Focus on Stryker." *Popular Photography* 51, no. 3 (September 1962): 60–65, 80–83.

"Editorial Comment: After Emergency, What?" *Florida Grower* 42, no. 8 (October 1934):18.

"Editorial Comment: Florida Sales Increase." *Florida Grower* 42, no. 7 (September 1934): 14.

Edom, Clifton C. "Photo-Propaganda: The History of Its Development." *Journalism Quarterly* 24, no. 3 (September 1947): 221–26, 238.

Embree, Edwin R. "Southern Farm Tenancy: The Way Out of Its Evils." *Survey Graphic* 25, no. 3 (March 1936): 149–53, 190.

"Editorial Comment: Florida Sales Increase," *Florida Grower* 42, no. 7 (September 1934): 14.

Evans, Walker. "The Thing Itself Is Such a Secret and So Unapproachable." *Image* 17 (December 1974): 12–18.

"Farmers Block Mortgage Sale." *Miami Herald*, February 15, 1933, 11.

"Florida's Optimism Once More Revives," *New York Times*, July 28, 1928, sec. 3, p. 1.

Girvin, Robert E. "Photography as Social Documentation." *Journalism Quarterly* 24, no. 3 (September 1947): 207–20.

Gray, L. C. "Florida Lands Gaining Wealth Under RA Care." *Miami Daily News*, March 21, 1937, p. 14.

Grubbs, Donald H. "The Story of Florida's Migrant Farm Workers." *Florida Historical Quarterly* 40, no. 2 (October 1961): 103–22.

Hardin, Thomas C. "The Photograph Is a Document." *News Photographer* 40 (June 1985): 10–11.

Harding, T. Swann. "What the FSA Is and Does." *Commonweal*, October 2, 1942, pp. 561–62.

Hartman, W. A. "Re-Vamping Land Use in Florida." *Florida Grower* 43, no. 11 (December 1935): 6.

Herling, John. "Field Notes from Arkansas." *The Nation*, April 10, 1935, 419.

Howe, Hartley E. "You Have Seen Their Pictures." *Survey Graphic* 29, no. 4 (April 1940): 236–40.

Johnson, Alva. "Tugwell, the President's Idea Man." *Saturday Evening Post*, August 1, 1936, 8–9, 73–74.

Katz, Leslie. "Interview with Walker Evans." *Art in America* 59, no. 2 (March–April 1971): 82–89.

Kimble, Eleanor G., "Footloose Families." *Survey Graphic* 68, no. 3 (May 1, 1932): 124, 161–63, 166, 168.

Levine, Robert M. "Impersonal Instruments." *Reviews in American History* 18, no. 2 (June 1990): 224–28.

Lorentz, Pare. "Putting America on Record." *Saturday Review of Literature,* December 17, 1938, 6.

Lusk, Robert D. "The Life and Death of 470 Acres." *Saturday Evening Post*, August 13, 1938, 5–6, 31, 34.

McCausland, Elizabeth. "Documentary Photography." *Afterimage* 12 (May 1985): 12.

Mallon, Paul. "News Behind the News." *Erie* (Pennsylvania) *Dispatch-Herald*, September 6, 1936, sec. 3, p. 6.

Pratt, Theodore. "Land of the Jook." *Saturday Evening Post*, April 26, 1941, 20–21, 40, 43.

"Reporter with a Camera." *Ebony*, July 1946, 24–28.

"Roosevelt Farm Tenancy Message." *New York Times*, February 17, 1937, p. 4.

Rothstein, Arthur. "The Picture that Became a Campaign Issue." *Popular Photography* 49, no. 3 (September 1961): 42–43, 79.

Severin, Werner J. "Cameras with a Purpose: The Photojournalists of FSA." *Journalism Quarterly* 41, no. 2 (Spring 1964): 191–200.

Shofner, Jerrell H. "Roosevelt's 'Tree Army': The Civilian Conservation Corps in Florida." *Florida Historical Quarterly* 65, no. 4 (April 1987): 433–56.

Snyder, Robert E. "Marion Post and the Farm Security Administration in Florida," *Florida Historical Quarterly* 65, no. 4 (April 1987): 457–79.

Stein, Sally. "FSA Color: The Forgotten Document." *Modern Photography* 43, no. 1 (January 1979): 90–98, 162–64, 166.

Stephens, Oren. "FSA Fights for Its Life." *Harper's*, April 1943, 479–87.

Stryker, Roy. "A Great Photo-Documentarian." *PSA (Photographic Society of America) Journal* 17 (April 1951): 182.

———. "The Lean Thirties." *Harvester World* 51 (February–March 1960): 6–15.

"Taxes: Mr. Tugwell's Ideas." *Time*, November 25, 1940, 86–88.

Taylor, Paul S. "From the Ground Up." *Survey Graphic* 25, no. 9 (September 1936): 526–29, 537–38.

"The Shape of Things." *The Nation*, November 28, 1936, 618.

"Tugwell: New Deal's Leading 'Red' Gets Job in Wall Street." *News-Week*, November 28, 1936, 16–17.

Tugwell, Rexford. "Behind the Farm Problem: Rural Poverty." *New York Times Sunday Magazine*, January 10, 1937, 24.

———. "Cooperation and Resettlement." *Current History* 45, no. 5 (February 1937): 71–76.

———. "Down to Earth." *Current History* 44, no. 4 (July 1936): 32–38.

———. "Resettling America: A Fourfold Plan." *New York Times Sunday Magazine*, July 28, 1935, 6, 12.

Vachon, John. "Commentary: Tribute to a Man, an Era, an Art." *Harper's*, September 1973, 96–99.

Walker, Charles R. "Homesteaders—New Style." *Survey Graphic* 18, no. 6 (June 1939): 377–81, 408.

"What a Dole Would Cost America." *Nation's Business* 20, no. 1 (January 1932): 80.

Wood, Violet. "Cranberries, Tomatoes, Potatoes and Onions," *Pilgrim Highroad*, July 1940, 15–17, 58.

Other Sources

Baldwin, C. B. Interview by Richard K. Doud. Greenwich, Conn., February 14, 1965. Washington, D.C.: Archives of American Art.

Hampshire, Gifford D. "The Documentary Approach." Address to the National Press Photographers Association, Hot Springs, Arkansas, July 5, 1973.

Lange, Dorothea. "The Making of a Documentary Photographer." Interview by Suzanne Reiss. Berkeley: Regional Oral History Office, Bancroft Library, University of California, 1968.

Rothstein, Arthur. Interview by Richard K. Doud, New York, January 1977. Washington, D.C.: Archives of American Art.

Stryker, Roy. Interview by Robert Doherty, F. Jack Hurley, Jay M. Kloner, and Carl G. Ryant, Louisville, Kentucky, 1977. Louisville: Oral History Center, University of Louisville.

Tugwell, Rexford G., and Grace F. Tugwell. Interview by Richard K. Doud, Santa Barbara, California, January 21, 1965. Washington, D.C.: Archives of American Art.

Index

Note: Page numbers in **bold** indicate photograph.